UNSOLVED
MURDERS
OF THE NORTH

UNSOLVED MURDERS
OF THE NORTH

JIM MORRIS

AMBERLEY

First published 2011

Amberley Publishing
Cirencester Road, Chalford,
Stroud, Gloucestershire, GL6 8PE

www.amberleybooks.com

Copyright © Jim Morris, 2011

British Library Cataloguing in Publication Data.
A catalogue record for this book is available from the British Library.

ISBN 978 1 84868 398 3

Typesetting and Origination by Amberley Publishing.
Printed in Great Britain.

CONTENTS

THE UNSOLVED MURDER OF...

A conviction does not always mean a crime is solved, it just means that some sort of 'end point' is reached. And an end is not always a finish. A murder is committed, an investigation ensues, clues are collected and interpreted, sometimes a suspect is identified – this brings in more clues and, at varying speeds, a picture emerges. Then that picture is tested, and if twelve people think that the picture presented is the right one, it becomes fact. Fact brings about a conviction – the jury are sole judges of fact – and conviction means the case reaches an end. This might take about fifty minutes on TV or a few hours in a book, but the reality is quite different: it might take years, decades, or even longer; or may never happen.

In 1910, Dr Crippen was convicted of murdering his wife and burying some of her in the cellar; just short of a hundred years later, scientists concluded there was a possibility the remains found in Dr Crippen's cellar were male, so that would take the investigation into Dr Crippen, or, more to the point, Mrs Crippen's fate, back to the start.

In the modern world, with technology and media as advanced as they are, there is a danger that the human faculty of judging fact will fall into disuse and therefore weaken. Often people are told what to think and what to feel, and that is what they do. And although there's no doubt this happens in a jury-room (there will always be, for instance, the arrogant who think they know everything, or the decision avoider who will follow anyone's lead, or the one who judges by appearance, and so on), one hopes that of the twelve people judging, at least the majority will do what is required of them.

But first a case has got to get to Court. For a long time now the media has told us that a certain amount of policemen will manufacture evidence in order to get a conviction, and although the Police will never admit to any 'departure from correctness', it does not help public confidence for this to be forever served up. The Police, though, are only a cog in a wheel. It then relies on the Court to sort out reality from fantasy; but that relies on the truth, the whole

truth and nothing but the truth to bind the story together. These days it is common to hear of 'new evidence' coming up, which often is not 'new' evidence at all, it is simply some piece of the story which was suppressed at the time. So unfortunately the truth, the whole truth and nothing but the truth can itself be a fantasy, and the entire Court procedure becomes a charade. And if the Court procedure relies, as it does, on the skill of counsel, then securing a conviction or an acquittal can mean a dangerously close encounter between a barrister's career and the interests of justice. If there is a hangman's noose at the end of it (as there is in one of the stories here) then it is plain to see why the capital punishment abolitionists must always win the argument.

Often people seem to miss the point, or at any rate an important point, when reading of a miscarriage of justice; and that is that the real culprit has got away with it and therefore is still among us. But this is true too for an unsolved murder. Fortunately most murders are domestic affairs and the so-called spree and serial killers are a rarity, though they do tend to grab the headlines. What does not grab the headlines is the mild-mannered farm labourer accused of murder, but with a clear alibi, wearing clothes he did not possess, ten years younger than the description given and without any reliable eye-witness, forensic or circumstantial evidence against him, who was convicted and hanged. But the real killer will not be found because, for now, the Police are not looking for them: the case, as they say, is closed.

When a suspect is wrongly convicted then that crime is unsolved too, sometimes it is left – for simple rural folk of the mid-twentieth century taking on the might of the State and the law was not for contemplation. Therefore, what is presented here is an interpretation of the facts of a case and a demonstration of its weak spots: this is not difficult because in this particular case there were no strong points.

In two other cases here, however, without the benefit of public help, the Police investigation quickly petered out. This is not to say that the public could have helped more than they did, but because one or two individuals either did not realise that the strange stains on the coat, or odd behaviour, or reaction to media attention to a crime was, in fact, evidence that could have helped catch a killer. Or they deliberately withheld information, or willingly helped dispose of incriminating evidence.

An elderly tool merchant is attacked and murdered in another case, but despite the most exhaustive investigation involving a number of different Police 'forces' no one was charged.

Another case shows how the trail can go cold when the wrong person is arrested and all Police activity is inappropriately focused. And, finally, where quite simply the Police did not know where to look – so looked at the '... most obvious suspect'. Wearing blinkers and not looking at the minor clues a miscarriage of justice was almost certainly the result.

Finally, and briefly, just a word or two about the collection of information. Most of the research for this book was done through the official records kept

at the National Archives in Kew, but the British Library Newspaper Section in Colindale was also a great help. In newspapers, the interpretation of facts has gone through several 'hands' so one never knows how much accuracy might have been lost. Moreover, the newspaper will tell only the newsworthy items and little details which could become crucial are soon buried under the more sensational stuff. But, in the National Archives, there are limits to what information can be released to the public, and most files are 'closed' for a minimum period – usually between seventy to a hundred years. This relates, of course to major crime files. There is a mechanism where requests can be made to 'open' a file early, but, in each case, if it is felt an exemption to the Freedom of Information Act can be applied the case will be tested and, for example, if members of the public who were involved in a case are still alive and they have given crucial information in a major crime enquiry, then the file is likely to remain 'closed'. Another example is where the 'public interest' may not be served, which might deal with specific Police methods.

All in all, the crime historian should avoid the sensational 'news' and concentrate on the nuts and bolts of a case and, in so doing, some truly startling issues can present themselves.

HENRY WARNER, LEEDS, 1948

By March 1948 the Double British Summer Time, which was present throughout the war, had been abolished and, on the night of Saturday 13/Sunday 14 March the clocks went forward by just an hour. But Henry Warner, who was unconscious in Leeds General Infirmary, did not notice any difference. He had been admitted to hospital in the late morning of Saturday 13 March with a severe head injury that was sustained in a vicious attack at his shop in the city centre, but it was complications in his recovery rather than the injuries per se, which caused most concern. He had emergency surgery, but it was a chest infection that killed him four days later, despite a slight improvement to his injuries.

Stephen Henry Warner was a seventy-seven-year-old leather suitcase and portmanteau maker who ran his own business from a basement shop at 62 Wellington Street in Leeds city centre. He was attacked with a 'blunt instrument', probably a packing case opener, at approximately 10.30 on that Saturday morning and left for dead. He was found when a Mr George Carr went into the shop; his friend, Mr George Gallomore waited outside, but Mr Carr was quick to summon his help.

The motive for the attack was thought to have been robbery, but Mr Warner's wife said he kept very little money in the shop. The shop was just about opposite to Leeds Central Railway Station and with the attack taking place in mid-morning, there would be a good few people milling around. It was not known how long he had lain in his shop after the attack, but Miss Margaret Battle, who worked in a nearby tobacco kiosk, saw him at 9.30 a.m. Just over an hour later she was called by the two men who had found him; he was lying on the floor with his eyes open, but was unable to speak. An ambulance was called and the Police alerted. Miss Battle described Mr Warner as '... mumbling, but we could not make out what he said.' She went on to say there was no '... disorder' in the shop, so there was no indication of any struggle.

Portrait of Henry Warner.

Mr Warner lived with his wife Kate, in Haddon Place, Burley; which is away from the city centre. Their children were grown up and had left home. His wife suffered chronic ill health herself and, each morning, Mr Warner would carry her downstairs before he went out to work and then carry her back up the stairs on his return home. Mr Warner had been in business in his shop for a number of years and, as the war passed and people were able to visit seaside resorts again for holidays, he had a steady stream of business coming in. Mr Warner was quoted to have said that he had been in business for '... over fifty years and have never known anything like it. Everyone going on holiday seems to want a trunk repaired.' A *Yorkshire Evening Post* reporter compiled a feature on Mr Warner only a few months before and described him as a '... craftsman of the old school.'

From the time of his admission to hospital the Police kept a vigil at his bedside, but he never regained consciousness, so was unable to help them with any details of his attacker. At the time of his death there were indications that his condition was improving, but the pathologist who performed the post-mortem described multiple head injuries. Strangely there were no other significant injuries, save for slight bruising on his ankle. Officially though, Mr Warner died from bronchial-pneumonia.

The murder enquiry was led by Detective Superintendent Bowman and the Chief Constable took a personal interest in the case. The Press was given what information the Police had in the hope of the public coming forward to help with any further information. By the Monday 15 March, the Police had

found what they thought was the weapon the attacker used. It was a heavy steel packing case opener which Det. Supt Bowman thought had been brought down on Mr Warner's head several times. This would have made a blood-spatter pattern if the attacker had lifted the weapon after each strike – so there would certainly have been blood on the attacker's clothes. And, when a blow was struck and the weapon made an impact on the skull, a small fragment of skull and blood may also have splashed off in a slightly different direction. Det. Supt Bowman concentrated initially on the small period of time from 10.30 a.m. to 10.40 a.m. If someone had passed by or had gone into the shop at that time, then they would have certainly seen the attacker.

Within a few days, several people had come forward to offer information but the Police were still looking for a solid way forward. On the Monday, Mr Warner's condition was described as critical. By Wednesday 17 March the Police had conducted well over a 1,000 interviews and had, Det. Supt Bowman said, '... descriptions of several people who were seen in the vicinity at the material time.' The steel bar, which the Police were certain was the murder weapon, did not yield any clues.

It was on Wednesday 17 March that Mr Warner died; the Chief Constable, Mr Barnett, described the crime as a '... gruesome and foul murder.' And he reminded the public that in a busy city centre a person (or persons) entered his premises and '... killed him for the sake of a few pounds.' He described his bewilderment that someone could enter and leave a premises without being seen. Mr Barnett said, '... at the moment we have no help at all.' He again appealed to the public for help. He reflected that '... the time has gone when we should creep about like Sherlock Holmes, looking for clues that had not been left ...' With remarkable candour he explained that only about a third of the crime committed in Leeds at that time was detected, so the old orthodox methods may have to be cast aside to try '... something new.' But there was, he said, '... nothing new in the suggestion that every member of the community was equally responsible for the good state of the community.' Publicity of the 'right kind' was the way to pursue the matter. A good relationship with the Press was a desirable link, but he was also shrewd enough to know that if nothing went to the Press, then nothing may come from the Press.

With Mr Warner being so busy with the rush for post-war holidays, his shop contained a large amount of items, so the Police asked customers who might have left goods at the shop to collect them on Saturday 20 March. In the event, about a hundred customers attended the shop and, after interviewing many of them, the Police thought they had gleaned some useful leads. After the last of the customers had left, they cleared the shop and made a thorough search for more clues.

The Coroner, Dr Swanton, had some harsh things to say about the public in relation to the murder when he opened the Inquest on Friday, 19th March: 'Those who can help and refuse to do so are passive accessories to the cruel

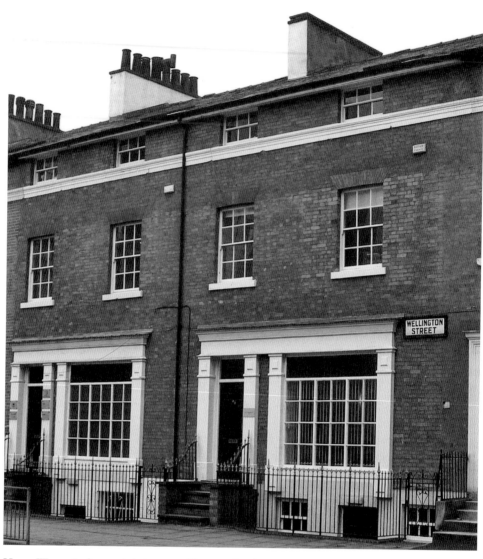

Henry Warner's shop as it is in 2010. The set of railings to the right of the view guard his shop.

murder of Stephen Warner.' The Inquest was adjourned at the request of the Police and would be re-convened on 15 April.

Mr Barnett ruled out the possibility of calling in Scotland Yard to assist with the hunt for the killer as he had confidence in his own men. A conference was called and senior police officers from other West Riding Constabularies were to visit the scene of the crime and then discuss possible ways of tracing the attacker. Some new leads were identified.

On 23 March, Mr Warner was cremated at Lawnswood Crematorium in Leeds. There was no service and, due to her own poor state of health, Mrs Warner was unable to attend.

Mr Warner's shop was on a main tram route through the city, a passenger had seen two men on the footpath outside the shop at about 10.30 on the morning of the attack. The passenger was so struck by their behaviour she quickly drew the attention of another passenger. Det. Supt Bowman thought this witness may have been able to help in the inquiry but, despite help from the Press, they were unable to trace her. It is quite possible that the witness saw the two men, Mr Carr and Mr Galloway, who had just found Mr Warner and were in the process of summoning help.

The Police followed up all avenues opened to them by the customers of Mr Warner after their attendance at the shop on 20 March. But for all their hard work and diligence, the attacker remained elusive.

It was thought the murder of Mr Warner bore similarities to another attack on a Mrs Annie Nicholls in a confectionary and tobacco shop in Broad Lane in Bramley, to the west of Leeds, in early 1945. She was struck over the head and strangled. A confession was made to this murder, but closer examination of the confession showed that the man who had made it was in Edinburgh at the time of Mrs Nicholls' death.

By the end of March, it was reported that the whole strength of the Leeds CID was dedicated to the murder enquiry of Mr Warner, and a reward of £100 was being offered. In early April, a man had come to the attention of the Police whom they interviewed at length, but he was later released without charge. As April moved on, another potential line of enquiry was followed up after another witness said he knew the identity of the killer, but after several hours of interviews the witness had not been able to help.

When Det. Supt Bowman attended the Inquest on 15 April he could only report that 'not much progress' had been made. The Inquest was adjourned until 15 May, and by then things had not changed, the question in everyone's thoughts was: '*Who was hiding the killer?*' The attacker's clothing would have been covered in blood stains, so someone, somewhere, knew something. Det. Supt Bowman told the Court, 'I am personally satisfied that there is someone in this city who could help this enquiry if they would come forward.' Was it fear or anxiety, or was there perhaps a misplaced loyalty preventing this? Or was someone unable to comprehend the facts that confronted them? Either way, in a short four-minute hearing, the Coroner asked if there was any further

evidence, which there wasn't. It was nine weeks since the attack and just over eight since Mr Warner had died. A verdict of murder by 'person or persons unknown' was returned.

Without any leads, the enquiry was destined to peter out and that is largely where the investigation was left. It would have been regularly reviewed, but neither arrest nor conviction ever came about.

WINIFRED SHARP, LEEDS, 1966

By the time peace reached the age of twenty-one, many scars from the war had healed and by the 1960s the post-war austerity gave way to a new generation. Rationing had gone, income tax was down, the average three-bedroomed semi had risen in price to about £3,800 and home ownership was rising. Black and white televisions saw their colour counterparts start to take over. In 1966, 38,610 motorists invested in the 0–60mph in 28.2 seconds Morris Minor. Shapeless demob suits had given way to casual clothes; jeans came into fashion and never went out. Men's hair grew right away from the short back and sides and coffee bars became the focus of the younger social scene. The American big-band sound passed out or on, and small groups of musicians with electric guitars led the way (ironically the No. 1 sound in the 'hit parade' in June 1966 was Frank Sinatra and the best-selling record that year was by Tom Jones!). In football, the maximum wage for players was abolished. Rock 'n' roll, football, and perhaps crime, were almost considered as careers; crime had taken on a little 'finesse'. In August 1963, the night mail train was stopped and robbed about an hour from London, but within a few months most of the gang were rounded up – and given prison sentences that were rounded up … to the nearest decade. With the prospect of a thirty-year sentence for armed robbery, most villains had a quick career re-think. It became as big a consideration to escape capture as it did to make off with the loot.

So, on 9 June 1966, in the centre of Leeds

It was at about 3.20 p.m that the shots rang out, and one of the witnesses even saw a man running, clutching a handful of bank notes. Mr Lawrence Twohey was a keen amateur Rugby League player with the Leeds Electric team, but he was recovering from a broken ankle so he could not give chase. But that broken ankle almost certainly saved his life because the man seen running from the Post Office in Bridge End in Leeds had just robbed it and, in the process, had shot two people; if the gunman had been cornered he would almost certainly have shot his way out of trouble, or at any rate, tried to. Considering Police

Portrait of Winifred Sharp.

statements issued later, that is not a wild assumption. Mr Twohey, though, went quickly into the post office to investigate. He found the sub-postmaster, Mr Geoffrey Flint, had been shot in the chest and his assistant, Mrs Winifred Sharp, who had propped herself up in the sitting position behind the counter told him: 'I've been shot in the stomach.' Mr Twohey called an ambulance and the Police, and Mr Flint and Mrs Sharp were soon taken to Leeds General Infirmary. The tragic news came about an hour and a half later that Mrs Sharp had died.

Mrs Sharp was fifty and married. She lived with her husband Ronald in Cross Heath Grove over towards Elland Road in Leeds.

Mr Flint was seriously injured, but he could still give the Police a description of the gunman. Mr Twohey could also assist by helping the Police to create an Identikit description. By the late afternoon edition of the *Yorkshire Evening Post*, an Identikit picture was completed and printed. The gunman was said to be about thirty, was 5 foot 6 inches to 5 foot 9 inches tall, with black hair, thin features and a sallow complexion. He was wearing a brown shirt or brown suede jacket (possibly a fake suede), drainpipe-style dark jeans with a hip pocket. Possibly he also wore sunglasses.

He was thought to be armed with a .32 revolver, and usually a revolver would carry six rounds – Mr Twohey's ankle may have prevented him receiving one or more of these. The gunman did not shout any warning in the post office; he just walked in and opened fire, there were no warning shots. The first bullet

The magnificent building with the rather tacky sign above the ground floor is the building in which Winifred was killed. The Bridge End Post Office was at the bottom of the picture to the right as we look.

hit Mrs Sharp and the second Mr Flint: a third bullet seems to have gone wide. Then he vaulted the counter and took up about £160 in notes before fleeing. He did not utter a single word throughout. His dangerousness was confirmed by the police officer assigned to take charge of the case. Detective Chief Superintendent Frank Midgeley of Leeds City Police said:

> There is no doubt about it, he was cold-blooded. I don't think he did this because he was being stopped. It was a cold, calculated deliberate act, and it suggests he is the type who would be prepared to use a gun again.

Another witness saw the gunman run towards the city centre. The Police were quick to act, road blocks were set up – buses, cars and lorries were stopped and searched. By 5.00 p.m. the City of Leeds was practically sealed off. Motorists were questioned about pedestrians asking for lifts; derelict property came under scrutiny. Detectives toured pubs and coffee bars to circulate the Identikit picture.

With the Identikit picture appearing so soon in the *Yorkshire Evening Post*, phone calls from the public began to pour in. Scene-of-crime officers and fingerprint specialists started the painstaking job of collecting all and any fingerprints from the post office. The Police called for the public to come forward for fingerprinting; they wanted to start the job of eliminating people. The Police hoped to identify everyone who had been in the post office anything up to a month before the shooting.

A Police spokesman said of the phone calls received:

'All these calls were followed up ... we were surprised at the speed the *Evening Post* got the description into print.' An operations room was set up at the Police Headquarters in Westgate, where a number of special telephone lines were installed.

A poignant sign was erected at the Bridge End Post Office: 'Temporarily Closed'. The Postmaster General, Mr Wedgewood Benn (Tony Benn), sent a message of sympathy to Mrs Sharp's family. And there was a £1,000 reward on offer for information leading to a conviction.

Phone calls continued to pour in with sightings of the wanted man. Detectives searched an area at Farnsley, near Leeds, after a report that a man matching the description of the gunman was seen running across an allotment. The search was later called off. No one was detained. DCS Midgeley said that over five hundred calls were received from the public during the first few days of the inquiry.

Meanwhile Mr Flint was progressing in Leeds General Infirmary – his wife, Pamela, cut short a holiday in the Channel Islands to return home. He was to have surgery to remove the bullet which was found to have lodged in his lung.

On the night of the shooting, a search was made of the River Aire in Leeds to see if the gunman had dumped the weapon, but nothing was found. Boarding houses were searched; unfulfilled bookings were examined for single men who had not arrived.

By Friday 17 June, with the inquiry in its eighth day, the Police got what might have been a break. A husband and wife on holiday from Florida, who had been taking photographs in the vicinity (one report said as close as 100 yards of the post office), were traced to Edinburgh. They handed over the film from their camera so the Police could process it. When the film arrived in Leeds it was quickly sent on for special processing to a photographic company in Wimbledon, South London. The film was sent by express train to London and the Metropolitan Police delivered it to the company. Unfortunately it did not provide them with the further information they had hoped for.

All leads continued to be followed up: 150 policemen continued the search for the gunman. A phone call told the Police that a man was seen at the Leeds Central Station helping a fellow passenger with their luggage, this was quickly followed up, and destinations of trains leaving at the time were checked.

But the gun and the gunman seemed to have vanished. There were regular meetings and briefings at Police headquarters; Leeds City Police also had conferences with other Yorkshire forces. This highlighted another cold-blooded killing of a young twenty-one-year-old RAF serviceman the previous October. Senior Aircraftsman Robin Draper of Burley-in-Wharfedale was shot dead as he was getting into his car in Mill Lane, Hawkswort. It was thought he disturbed a man at his car after he returned from spending the evening at the nearby home of his girlfriend. He died almost immediately from a single wound in the stomach caused by a small calibre weapon. There were differences in the descriptions of the two gunmen, which would be expected: in the one incident the shooting happened at night and in the other the speed at which the incident unfolded would have given witnesses little time to collect their thoughts. But the method of the two attacks was similar. The weapon was said to be similar too, but there was no information forthcoming about a ballistics examination.

Slowly the odds were beginning to pile up against the Police catching the man. No one came forward who had seen anyone loitering around the area – if he was a local man then no one identified him. Most, if not all, detectives would have had their informants, but little, if any, information came in from them. Clearly the motive for the shooting was the robbery – but the fact was he had shot at people without compunction or any regard to how badly he might have hurt them. It did not seem to be that he wished to frighten them into compliance, he prevented the staff in that post office of having any means of resisting the attack or of raising the alarm; the raid was carried out with a rapid and ruthless efficiency.

The Police needed information. Once a villain flees from the scene of a crime his identity flees with him, his anonymity grows as he blends in with the population. By the time he has run a hundred yards and turned a corner, witnesses only see a man in a hurry; by the time he has run another corner he becomes the man who was moving rapidly along. And into and out of a department store; he is just one of the crowd. The problem for detectives was how many men were there in Leeds, who were resident and on foot so not likely

to be found in a vehicle search, were between 5 foot 6 inches and 5 foot 9 inches tall and around thirty years of age? And within ten minutes or so of the shooting he could have arrived at Leeds Central Station. With this man's callous disregard for the safety of others it is quite possible he calmly boarded a train.

One suggestion was that he may have made his escape by car. A car bearing the letter 'C' after its numbers, suggesting it was a 1965 and therefore a fairly new model, was reported to have been travelling south-east towards Castleford. The driver stopped and asked directions on the southern outskirts of Leeds. Whether this driver was traced or indeed the car was stolen is not known.

The photographs from the American tourists were taken far earlier in the afternoon than first thought. But there were other photographer's reported in the area. Police were keen to trace them as they were seen at the junction of Lower Briggate and Call Lane at just about 3.20 p.m., which is the approximate time of the shooting. Unfortunately they were not traced.

The inquest on Mrs Sharp opened on 22 June. The Coroner, Mr Douglas Bywater heard Dr Colin Manock give evidence of the post-mortem – Mrs Sharp died of shock and haemorrhage due to a gun-shot wound. Mr Ronald Sharp also gave evidence. Predictably the inquest was adjourned.

By mid-August the crime remained unsolved. But a man was arrested and charged for shop-breaking, he was set to appear before Magistrates in Leeds. The Police issued a statement confirming this, but also said he was to be the subject of further enquiries. He was said to be 'helping the Police with their enquiries' in relation to the murder of Mrs Sharp, but no charges were brought.

The killer's haul was not huge at £160, the equivalent (at a rough estimate) by 2010 would be about £2,500. It is a matter of speculation as to what preparation went into the robbery, as to whether he knew the layout of the shop and if, at that time of day, trading was quiet. What is known is that when he went into the post office there was only Mr Flint and Mrs Sharp present, and that he passed a customer on his way in. Thereafter it is his speed and economy with his firearm – he only used three bullets to block the raising of the alarm. With agility, he vaulted the counter. And he was gone. If anyone had followed him into the shop, either the plan would have been abandoned or a fourth shot would have been fired. In one sense the robbery was opportune; it was in his plan to evade capture that he left nothing to chance.

EMILY CHARLESWORTH, SCUNTHORPE, 1945

The small village of Swinton in Yorkshire lies about eighteen or so miles to the north-west of York, not far from the town of Malton on the main road from York to Scarborough. Just west of Swinton is another tiny hamlet of Appleton-Le-Street. This is rural Yorkshire and for John Harrison, a stone mason, seeing his family grow around him was a joy. His wife Maria bore him eight children and the second eldest, Mary Emma, was to trade the tranquillity and beauty of the countryside for the industrialised and comparatively drab life of the town; but not until her own marriage. Mr Thomas Samual Ramshaw married Miss Mary Emma Harrison in Malton in the spring of 1893 and the couple settled in Scunthorpe, where Thomas worked as a mills man in a steel works.

They had a daughter, Ida, born in 1894; and then sons: Thomas Henry – known as Harry – who was born in 1896, and William followed about two years later, in 1898. But also in May 1898, Thomas Samual died, he was only forty-two. Mary did not remarry.

The family lived in the centre of Scunthorpe in No. 4 Ravendale Street, which is just off the High Street and, after her husband died, Mary took in lodgers to help pay the way. Her last child, Herbert Ramshaw, was born in 1902, so the lodgers may not have been quite the blessing Mary thought they might be! And, sadly, she was to also die young, at forty-three, in August of 1911. Their aunt, Miss Emily Harrison took over as their guardian through the boys teen years; Ida went to live with her grandmother in Hull. Miss Harrison left to get married in September 1912 and her other sister, Ellen took over. Ellen Harrison died in 1918. At this point the youngest brother, Herbert, went to live with his Aunt Emily who was now Mrs Emily Beacock, leaving just Harry and William; another housekeeper came and went within a few months.

Harry and William had left school and took up jobs as errand boys. The main industry in Scunthorpe was steel, and so Harry later went to work in one of the big steel mills, John Lysaght's. He was employed in the blast furnace department and stayed there for the majority of the rest of his working life.

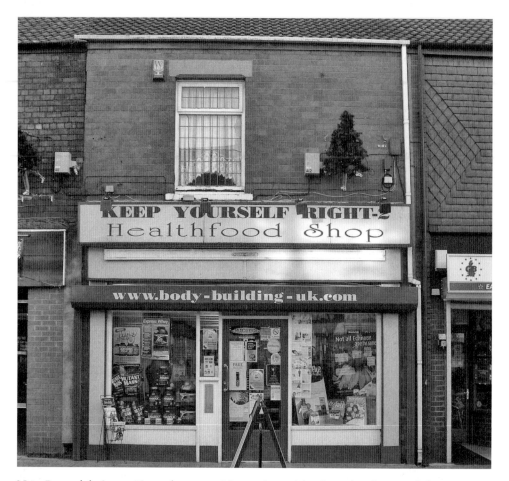

No 4 Ravendale Street, November 2010. Now a shop with a burgular alarm and christmas tree give no clues to its tragic past.

He never married and lived in the house in Ravendale Street for many years to come.

Just after the end of the First World War they brought a new housekeeper to Ravendale Street, a Miss Emily Jane Charlesworth. She was in her early forties and brought the lads the stability they needed. She was to serve them loyally for the next twenty-seven years.

Miss Charlesworth was actually born in Sowerby Bridge in Yorkshire, but her family moved south to Lincolnshire in the late 1880s. Her father, Joe, was a bookkeeper and he too was employed in the steel industry. Miss Charlesworth had an elder sister, Lily, and several younger siblings. She spent nearly all her spare time on church activities and had been involved with her church since she was a little girl. In the late summer and early autumn of 1945, Miss Charlesworth was as busy as ever selling tickets and helping to arrange the

up-coming Harvest Festival. Some of these jobs were a little mundane but essential, and Miss Charlesworth was said to be industrious and thorough in what she did. She was known in the neighbourhood as a quiet, unassuming woman. St John's Church is a magnificent building in Church Square, which lies at the eastern end of the High Street and is under a mile from where Miss Charlesworth lived.

In 1945, the north end of Ravendale Street was mainly comprised of terraced residential property, which had been closely built towards the end of the nineteenth century. As time moved on, small businesses were to spill over from the High Street into Ravendale Street; but at this time that had not yet happened. The layout of the house meant that the kitchen was at the rear of the house and faced out onto a backyard, and there was a ten foot-wide public way running across the rear of the yard – known as 'the ten-foot'. The parlour at the front of the house looked out onto the Ravendale Street footpath.

It is not clear what happened to William Ramshaw but one report says Harry 'put him out of the house as he had been stealing from the housekeeper's box'. Miss Charlesworth ran collections for various causes.

In late September 1945, Harry was working night shifts at the steel works. He was usually ready to go to work by about 9.30 p.m. for a 10.00 p.m. shift start. It was at the usual time on the Saturday night of 22 September that Miss Charlesworth saw him off at the front door, she said:

'It is time you were going to catch the bus. Goodnight. Do be careful Harry.'

This was their normal routine and he was to say that he did not notice anything unusual in her manner that night; if she had been expecting visitors she would have told him, but it was not her habit to take visitors after about this time in the evening.

Harry left work the following morning and arrived home at about 6.15 a.m., but he was surprised to find that the back gate was partly open; the back door of the house was closed, but he discovered it was not locked. It was usual for Miss Charlesworth to be up waiting for him to come home after a night shift, and she would usually open the door when she heard him. Harry opened the back door and called her name. He did not received any reply, so he went into the house. Soon he found her lying motionless on the floor in the kitchen, he again called out to her, but she did not answer. She had died sometime after he had left for work the previous night, her killer had beaten her about the head severely and had rained so many blows on her face it made her unrecognisable. She was sixty-nine.

This was a situation few people would be prepared for. Harry was almost at once in shock, and he ran from the house in search of assistance. Robert Street cuts across Ravendale Street, about thirty yards to the south of Harry's home; it was here that he met Mr Ernest Dennis. Mr Dennis later said Harry was distraught and crying, he had told him his housekeeper was dead, but Mr Dennis said he could not get a lot of sense from him. He suggested to Harry that they should notify Miss Charlesworth's relatives to try and obtain

Portrait of Emily
Charlesworth.

some assistance. A Miss Florence Thompson, who was Miss Charlesworth's niece, was called on. Harry roused her from her sleep to tell her of the events; she telephoned the Police and arranged for a doctor to attend Ravendale Street. Dr Herbert Collins went to the house, but did not give more than a cursory glance at Miss Charlesworth because it was so obvious she was dead, he knew it was more important that the scene was undisturbed so as to aid the Police who were inevitably to be involved. He was to say that her face was terribly disfigured; barely was there a face left. She was lying on her back with her arms and legs outstretched. Dr Collins did not stay at the scene for long.

In those days, the parlour was the sitting room where visitors were usually entertained, and typically people would use the kitchen as their living room. And it was in the kitchen that Miss Charlesworth was found; one commentator referred to it as the 'living kitchen'. Apparently she was still in her day clothes and it was reported that pots were laid at the table. Miss Charlesworth had been dead for a number of hours.

The Police were quick to move into operation. Superintendent Reginald Knowler was to take charge of the enquiry. The decision was made that help from Scotland Yard would be requested. The Home Office Pathologist for the area, Professor James Webster, was to perform the post-mortem. Scotland Yard responded to the request for assistance and a Detective Chief Inspector Arthur Davis and Detective Sergeant Christopher Wolff arrived up from London on Monday 24 September. The local Police in Scunthorpe had taken the fire irons,

which were splashed with blood, and a badly damaged and blood-stained bread knife for tests.

A courting couple who were thought to have been in the vicinity of the rear of the property on the Saturday night were asked to come forward.

*

The inquest was opened on Monday 24 September, and the coroner, Mr Eric Dyson, said he had summoned the jury to inquire into the circumstances of Miss Charlesworth's death. Supt Knowler advised the Court that it may be quite some time before the Police had the evidence the Court would require. DCI Davis and DS Wolff were also in attendance. The jury had elected a foreman, so Mr Dyson could at least record the identification of Miss Charlesworth, and record the preliminary observations.

Harry was called as the first witness. He could tell the Court that he was actually born at No. 4 Ravendale Street and had lived there all of his life. Since his parents had died and his siblings had moved on, he was left as the sole tenant. He had been employed for many years as a skip filler by a local steel mill of John Lysaght's, and he worked mainly in the blast furnace department. Harry gave the Court a brief summary of the Sunday morning in that he arrived home from work at just before 6.30 a.m. and found her body in the kitchen on the floor in front of the fireplace. At first he said he did not recognise her face because it had been so severely beaten. Mr Dyson asked:

'Did you doubt that it was Miss Charlesworth?'

Harry replied:

'No. I knew it was her. I identified her by the shape of her figure. It was about the same height and build.' Harry went on to explain that her clothing had aided his identification – he recognised her jumper.

It would be Miss Charlesworth's usual habit, he went on to explain, to mention to him any visitors she might have been expecting in the evenings. Although some people visited unannounced at odd times, such as her sister or brother who lived in Ashby, but Harry said he could not remember her ever having visitors after about 9.30 p.m.

A niece of Miss Charlesworth's, Mrs Edna Warner, told the Court that she was the daughter of Miss Charlesworth's sister. She said she had not seen her aunt since about the middle of August of 1945, but at that time she said she had appeared to be in normal health and was quite cheerful. Mrs Warner had gone to the mortuary to identify the body and by reference to the size and build of the body she saw, Mrs Warner was sure it was that of her aunt, Miss Charlesworth. Detective Sergeant Leslie Kirby had also shown her several items of clothing, which included a dress that she knew belonged to her aunt. There was also a cardigan, which she knew had been knitted by her sister, another niece of Miss Charlesworth's. And also there was a jumper and a single shoe.

This was about as far as the inquest could be taken for the moment. But Mr Dyson asked Supt Knowler:

'I believe you are following up a line of inquiry?'

Supt Knowler replied:

'Yes. The inquiry is, of course, in its initial stages. We have the Scotland Yard officers with us. It may be some weeks before we are in a position to give you the evidence you require.'

Mr Dyson said he hoped the Police would be able to obtain the help of the public, which Supt Knowler endorsed. As the Press was present for the hearing, Mr Dyson reinforced the Police appeal for anyone who had been in the vicinity of Ravendale Street on that Saturday night/Sunday morning, to come forward.

The report from Professor Webster's post-mortem had not yet been made available, so this, together with Supt Knowler's suggestion that it might take a few weeks to consolidate the evidence, was enough to prompt Mr Dyson to adjourn the inquest for four weeks. So the inquest was formally adjourned, and would be resumed at the Scunthorpe Police Station at 3.00 p.m. on 24 October.

<p style="text-align:center">*</p>

A leak of information fuelled speculation before the official release of the post-mortem report, that Miss Charlesworth had been partially strangled before she was struck a number of times on the head and face. Professor Webster's report had not yet been made public when these revelations were made, and it is not clear where the information came from.

It was rumoured that she was probably unconscious when the fatal blows to her head were struck. This suggests the strangulation was to render her unconscious after which she was bludgeoned. But it seems an odd way to go about things; considerable effort would have been needed to cause such serious injury to her face, although it would mean identification could not be made by the usual recognition. But that is assuming the blows and facial injuries were to prevent recognition, it is impossible to be definite but as Harry and Mrs Warner were both able to identify Miss Charlesworth by her size and shape to the satisfaction of the coroner, then such a matter may be trifling. The bludgeoning is a feature of the case which will be discussed again presently.

After the initial examination of the scene of the crime – there was no reason to suppose the crime had taken place elsewhere – a number of clues were to be a focus of the Police as they searched for further information. Neither Harry nor Miss Charlesworth were noted for alcohol consumption so when an empty Guinness bottle was found at the scene it drew attention to itself. The Police therefore asked the public to think back to the Saturday night and if anyone was seen with a Guinness bottle, then they would like to hear from them.

Speculation continued as to the contents of Professor Webster's post-mortem report, and again the possibility of manual strangulation was cited.

It was felt she was likely to have been unconscious when she was battered – the speculation was mounting that this was to effect identification. But this is only one of the features of this case that is still unsatisfactorily accounted for, and there was another odd move by the Police which is worth consideration.

An announcement was made in the *Scunthorpe Telegraph* that because the case had inevitably caused some alarm to local women, there was no evidence to support fears that there '... may be a homicidal maniac in the district.' It was reported that as there was no history of previous attacks on woman then there was no justification to the belief. But one wonders then about the first victim of a 'homicidal maniac'. And in their notes and reports the senior police officers said the murder *was* the work of a homicidal maniac. If the supposition is that Miss Charlesworth had first been strangled then it was said her assailant may have '... inflicted the facial injuries as a sign of their own evident fears,' then the reassurance does not make sense. The release of information does not show the danger was minimal, rather it is just indicative of an assumption by the Police; and one is compelled to consider there was something more the Police knew which was not officially recorded nor made public. It was also strange to claim the work was not of someone whose rationale appeared off focus, that is to say 'a maniac'. As the claim was made that Miss Charlesworth was strangled into unconsciousness and then battered, it begs the question: why not finish the job as started? Battering a dead person's face might take a lot more effort than strangling an unconscious woman, and battering someone would give two lots of blood splatter pattern – one as the weapon impacts on the victim, and the other is after each blow, as the weapon is lifted in readiness for the next blow, it will drag blood and tissue from the victim for dispersal. The assailant, therefore, is going to have a good deal of blood on their clothing, which would be avoided if the easier path of completing the strangulation was pursued. It was recorded that blood had spattered onto all four walls of the kitchen and had also reached the ceiling. This case can only make sense if all the facts are known, and what facts have not been recorded are anyone's guess.

But as she was found in the kitchen of the house she lived in, and in her own clothes, then would this dilute the effect of the question as to why her features were so damaged?

*

The funeral was held on Tuesday 25 September and several hundred people turned out to pay their respects at her church, St John's. Only a fraction of the crowd could get into the building, and they were mainly other members of the congregation Miss Charlesworth had known since she started to attend the church in her early childhood. It was reported that there was a real atmosphere of tribute and sorrow. Many of the congregation were greatly shocked by the

The church Emily attended nearly all of her life and where her funeral ceremony took place.

turn of events, and their grief and bewilderment that: '... so unassuming and gentle a woman should become a central figure of so senseless and brutal a crime' was very plain.

The Minister, Revd Swaby knew her well and an old friend of hers was also at the organ. Revd Swaby addressed the few relatives who attended:

> I could have said a lot more about the way she met her death but that would not help you at all. But I do ask you to believe that the congregation of this church values very much the long years of work which your loved one did.

Miss Charlesworth was buried at Brumby Cemetery, which is within the Scunthorpe borough boundary.

Revd Swaby said later that Miss Charlesworth was one of those very quiet people who did not want to be in the limelight and never had been:

But she did a lot of small jobs in a very thorough way – tasks like the distribution of church magazines and selling tickets for church events. It is not always realised how important these jobs are and how hard they can be.

Revd Swaby hoped that anyone who could respond to the Police appeals for information would do so.

<div align="center">*</div>

The investigation was gathering momentum with both the local CID, under Supt Knowler, and the two Scotland Yard officers pursuing a definite line of enquiry.

A broken pair of spectacles, or a part of them, was found and handed over to the police officers – this was one example of many where the public were assisting the Police with their inquiries. The Police had made yet another close examination of the house, DCI Davis said he visited the house for the first time on 27 September – three days after his arrival in Scunthorpe.

More public co-operation had also been forthcoming in connection with the appeal to a courting couple thought to have been in 'the ten-foot' way behind the house on the Saturday night. Officers investigating the case interviewed a number of people who saw this couple and had obtained descriptions of them. But the couple had remained elusive and had not come forward. The Police could not emphasise enough the importance they attached to information which this couple might have been able to give them. The couple were not thought to have been involved in the crime and may have thought they had nothing to say of importance, but it was stressed that even if their information was negative it might be helpful in the verification of the known facts.

As time went on and the couple still did not make contact it was thought possible that other reasons prevented the couple coming forward – possibly personal reasons for not wishing to admit their presence, the Police made it known that they did not wish to learn anything other than facts pertinent to the enquiry and asked if just one of the couple could come forward. Again there was to be no response.

Another possible witness the Police wanted to speak to was a man seen in the area; he was aged about twenty-five to thirty, about 5 foot 9 inches tall with a fresh complexion, but large, staring eyes. He was wearing a khaki beret and a civilian raincoat.

But the Police had a definite line of enquiry they wanted to follow, and although no rapid results had materialised, they remained dedicated to this. In the second week of the investigation the clues they would publicly admit to were just the physical items from the scene of the crime: fire irons found at the house, a damaged, blood-stained bread knife and a Guinness bottle.

But they were still eager to trace the couple who were at the rear of the house between 9.30 p.m. and midnight. Eventually this couple came forward and gave good corresponding accounts of what they witnessed or did not witness in 'the ten foot' that Saturday evening. They gave widely differing accounts of how they had come to be there; and this demonstrated that their main core of information, as to what they saw and heard was sound and they had not colluded about what they would say. They were married, but not to each other.

<center>*</center>

And then came the announcement the town had been hoping for – an arrest. A forty-nine-year-old local man, who knew Miss Charlesworth very well, was arrested and charged with her murder. He appeared in Court on 3 October 1945, it was Harry Ramshaw.

So much was the strain put upon Harry that when he appeared in Scunthorpe Magistrates Court he had to be physically supported by two policemen. Supt Knowler handed the submissions book to the Magistrate, which was not read out to the Court, but the officer was required and swore that the contents were true.

The Clerk of the Court read out the charge:

'That he, Thomas Henry Ramshaw on the 22 September 1945 in the parish of Scunthorpe, feloniously, wilfully and of malice aforethought did kill and murder Emily Jane Charlesworth, against the peace of our Sovereign Lord the King, his crown and dignity.'

Supt Knowler explained the history of the morning of 23 September in that Miss Charlesworth was found in the living room at No. 4 Ravendale Street with injuries to the face. The Police had been summoned and, by the following day, the Chief Constable had secured the services of DCI Davis and DS Wolff who shortly after arrived from Scotland Yard to assist with the enquiries.

Harry had made a statement to DS Kirby who had cautioned him and told him he was to be arrested and charged with Miss Charlesworth's murder. Harry had replied:

'I have told Insp. Davis all I know. And that is the truth.'

The Chairman of the Magistrates, Alderman John Tomlinson, asked Harry if he wished to ask any questions, to which he replied he did not. Supt Knowler applied for a remand in custody until 23 October, which was granted. Harry was asked if he had made any arrangements for legal representation, which he had not; so he was given a certificate for Legal Aid before he was led away by the two officers.

<center>*</center>

By the time of his next appearance before the Magistrates on 23 October, the legal machinery had started to grind into action. Harry was represented by

a Mr T. J. Lewis; and for the Director of Public Prosecutions was Mr John Claxton. The Chairman of the Magistrates was again Alderman Tomlinson.

Mr Claxton presented the facts of the case, or at any rate the facts that were known, to the Court: Miss Charlesworth had been the housekeeper for the Ramshaw brothers, and latterly for Harry, for a number of years. Mr Ramshaw had been employed in Lysaght's steelworks and was currently engaged on night shift. He therefore spent his day sleeping.

A Mr Dennis had been in Robert Street (adjacent to Ravendale Street) at about 6.00 a.m. on the Sunday (22 September) when Mr Ramshaw approached him. He was very distressed and crying; he blurted out that his housekeeper was dead. Unfortunately Mr Dennis could not get much sense out of him. He felt that the housekeeper's relatives should be contacted and they could look after things. Mr Ramshaw had sought the help of Miss Charlesworth's niece who lived close by. She telephoned the Police and arranged for a doctor to attend No. 4 Ravendale Street.

A Dr Collins attended the house later that morning; Mr Ramshaw and Miss Thompson (the niece) waited outside. Dr Collins did not make a close examination of Miss Charlesworth as it was clear she was dead. He quoted:

It was quite obvious – one glance was sufficient – that Miss Charlesworth was dead. Her face was terribly disfigured. In fact there was no face left. Miss Charlesworth was lying on her back with her arms and legs outstretched.

Mr Claxton continued. Police Sergeant David Ogilvy arrived who stated he met Mr Ramshaw at the back door. He reported Mr Ramshaw was crying; he said the doctor had been and had advised that it was now a matter for the Police.

PS Ogilvy confirmed that there was a body lying on the ground, that there was blood on the floor and blood splashed on the wall. stuck on to the hearth in front of the fire was a shoe, which belonged to Miss Charlesworth. It was still buttoned. PS Ogilvy spoke to Mr Ramshaw who told him:

'I came in this morning and found her lying there, her face covered in blood. I spoke to her and she did not speak. She was alright when I left her at 9.20 last night to go to work.'

PS Ogilvy locked the door and went to report to his superior officer. Shortly after, he returned to the house and waited until DS Kirby arrived.

Mr Claxton went on to say that Miss Charlesworth had been wearing stockings, which had blood on each of the knees. Her clothing was disarranged. Her dentures, both upper and lower, were on the carpet just above her head. A pair of spectacles were entangled in her hair and a broken lens was in a pool of blood, and a broken earpiece was near her head. A bent brass fire poker was found under the table. The handle of the brass shovel was in the fireplace. There were blood spatters evident on the poker and the shovel. There were various pieces of bone matter on the floor and around the room. Also in

the room were an empty Guinness bottle, and various items of crockery and cutlery. A breadknife which had blood stains on it had the blade bent at right angles half way down its length.

DS Kirby went to see Mr Ramshaw, who told him that it had been a great shock to him. He made a statement. On Saturday 22 September, he spent most of the day in bed, and Miss Charlesworth called him at 8.00 p.m. to get ready for work. He had a cup of tea with her and listened to the wireless. He left the house for work at 9.30 p.m., Miss Charlesworth came to the front door with him and told him to be careful. She would lock the door after he left.

He clocked in at work between 9.55 p.m. and 10.00 p.m. and left at 5.45 a.m. on the Sunday morning, 23 September. When he came home from work he went in the house through the back door, the gate was partly open and the back door was closed but not locked. It was Miss Charlesworth's practice to be up waiting for him to come home, and to open the door when she heard him. But on that Sunday morning Harry opened the door. His statement concluded that Miss Charlesworth was alone when he left her, and as far as he knew she was not expecting anybody.

Mr Claxton said that Professor Webster, a Birmingham-based Home Office pathologist, who performed a post-mortem examination, had submitted a full report of his findings. His conclusions were that this lady had been relatively healthy and did not die from natural causes. 'In addition to gross injuries inflicted on her head and face by a sharp instrument and a blunt instrument, it was quite clear that she had suffered manual strangulation and had received further injuries to her head and face after death. She had put up a fight for her life, and it was clear from the bruises on her hands that she had tried to ward off the blows directed at her. Death was due to manual strangulation, accelerated by shock, from the multiple injuries to the face and head.'

It appeared that a few of her acquaintances knew of her nervousness about being in the house alone when Harry was at work. Miss Lillian Naughton could tell the Court that she knew that Miss Charlesworth always kept the back door locked when the accused was on night duty. She also kept the back garden gate bolted, with a brick at the bottom because she did not want strangers or unwanted guests at night.

Harry had arrived at work at about 10.00 p.m. that Saturday night, where he was seen on his employer's premises and stayed there until approximately 6.00 a.m. the next morning. When he returned to his house, he found Miss Charlesworth dead.

Witnesses were called, and evidence regarding the removal of the body, the post-mortem and the inquest were given by Police Constable Leslie Humby.

Miss Naughton said she went to Miss Charlesworth's house at 3.30 p.m. on 22 September and left about 4.15 p.m. Miss Charlesworth appeared to her to be in quite good spirits. She had stayed with Miss Charlesworth and knew that it was her custom to lock the doors at night, and keep a brick behind the garden gate.

Mrs Margorie Cooper said that she passed Miss Charlesworth, who was standing on the doorstep of her house, at about 6.30 p.m. on the Saturday, and they spoke to each other.

Mr Fred Cullen, a skip filler employed by John Lysaght's said that Harry arrived at work just before 10.00 p.m. on 22 September. He said he had always been a quiet man and never joined in conversation in the cabin, and he was just the same as usual that night. They were together all the night until he, Mr Cullen, left at 5.40 a.m. the next day. Mr Cullen was specifically asked about Harry's behaviour that night and he was adamant that during the whole of the evening he had behaved exactly as he did every other night. This was reinforced by other employees from Lysaght's.

On the second day of the Magistrates hearing, Mr Vivien Hunter, assistant manager of the Scunthorpe Gas Department, said that he had examined the gas meter at No. 4 Ravendale Street and found that it would pass a small amount of gas without the insertion of coins. (DCI Davis had said a witness had stated that a light was seen on in the bedroom at about 10.00 p.m.)

When DCI Davis was called to give his evidence, Mr Lewis (for the defence) asked that DS Wolff should remain in the witness room.

DCI Davis said that he came to Scunthorpe on 24 September. He went to No. 4 Ravendale Street on 27 September, and saw the deceased woman's relatives there with Mr Ramshaw. Also present had been Supt Knowler and Detective Constable Cyril Clarricoates.

He had asked Harry about the back door. DCI Davis was told that Miss Charlesworth always locked the back door before Harry went to work at night, but he could not remember if she locked up on that Saturday night. Harry told him that when he came home on the Sunday morning he found the gate open and the back door unlocked. The gas light was on, but going down, so he turned it out. He looked down and saw Miss Charlesworth was dead.

DCI Davis asked how he could see her if the light was out, and Harry replied:

'I saw her alright, and it upset me so I ran and stopped a man in the street.'

He added that the back door key was in the lock on the inside. He said the accused then started to cry and said he could not remember any more.

On 1 October, DCI Davis saw Harry again, and asked him further questions. All he would say was:

'I cannot remember. I did not kill her.'

DCI Davis said he suggested that they went to No. 4 Ravendale Street, as it might possibly assist his memory. So they went there, and Harry showed him how he entered the house. DCI Davis said he became very excited and kept saying:

'I left her in the best of spirits. I did not murder her. I did not even touch her.'

They left the house, and as they were getting into a car Harry had became very agitated and said:

'I did not murder her. You are going to charge me.' He was told he was only being questioned. They went to the Police Station, where he made a statement. After he had made the statement Harry left to get into a police car and he said:

'Shake hands, sir. You have been very kind to me, but I did not do it.'

They shook hands and he said to Harry:

'I shall see you tomorrow after you have had a night's rest, as I still have a number of questions to ask you.' Harry replied:

'I wish it was all over and I could remember. I cannot remember touching her. I could not help it. I do not remember.' The following day at 11.30 a.m. DCI Davis saw Harry again and told him he had further questions to ask him. Harry said:

'I do not want to go down the line or get a life sentence for it. I cannot remember what I have done.'

After he had been cautioned, Harry said he would write a statement down himself, but would need help with spelling and grammar. He said:

'I am sorry I done it and all the trouble that has been caused.' He wrote his statement, starting at 11.55 a.m. and finishing at 2.58 p.m., with an interval for lunch from 1.30 p.m. to 2.00 p.m. When he had finished he asked to leave the Police Station, but was told he would be detained. He was detained, cautioned and charged. He said:

'I have told Insp. Davis all I know. It was the truth.' DCI Davis put this in his statement but Mr Lewis, for the defence, objected to this being put in on the grounds that '... they were not the free and voluntary statements of the accused.'

Cross-examined by Mr Lewis, DCI Davis said that apart from the fact that Harry was the last person to see Miss Charlesworth alive and the first to find her dead, he suspected him because he could have committed the murder. But the question of opportunity needs some discussion.

The following exchange is from the cross-examination of DCI Davis:

DCI Davis: 'Also from my information, the body had been moved after the murder and not a single clue or fingerprint of the accused was found on the premises. This was strange to me seeing as the accused had resided at this address with the deceased for twenty-seven years.'

Mr Lewis: 'Are you suggesting in telling the Court of that last suspicion of yours that the accused had removed all traces of fingerprints from every and any article in the living room after the crime?'

DCI Davis: 'I make no such suggestion.'

Mr Lewis: 'Is not that the logical conclusion?'

DCI Davis: 'Some persons might infer that.'

Further cross-examined, DCI Davis agreed that a Guinness bottle found in the house had fingerprints on it, but they were not Harry's. The Landlord of the

Oswald Hotel, where the bottle might have come from, had said that he could not remember seeing Harry in that hotel at any time. DCI Davis added that he was aware that, in a statement to the Police a woman had said that she saw a light in the bedroom at No. 4 Ravendale Street at 10.00 p.m. on 22 September.

The magistrates remanded Harry to appear at the next Lincoln Assizes.

However, to reflect on a couple of the points DCI Davis made, it is next to impossible to remove all of one's fingerprints from any scene where one has lived for a long period. For one thing, they are practically impossible to see with the naked eye. So this is nothing short of bizarre. Harry had lived at No. 4 Ravendale Street all of his life; and to find fingerprints, one has to look for them first. Moreover, to get to the house from his work without being missed, without being seen, sounds a bit of a tall order, made taller by his colleague saying they had been together all night.

So, as noted above, the opportunity just did not seem to be there. If he caught a bus at 9.30 p.m. for a 10.00 p.m. shift start then he was at least twenty minutes each way from the scene; he would need perhaps ten minutes to do the deed. And what did Harry wear, because whatever it was, there would have been a lot of blood, a few fragments of bone and bits of brain tissue flying around the room, yet none were found on any of Harry's clothing. And it was confirmed the clothing examined had been worn for several days prior to the event.

But the time of death does not seem to feature in the detectives' deliberations. Dr Collins estimated with the consideration of how far rigor mortis had set it, which led him to conclude Miss Charlesworth died at around midnight. Professor Webster actually requested information regarding her last meal; Harry said she had eaten bread and butter at about 8.20 p.m. Professor Webster did find bread and butter in her stomach and intestine and assessed that she had eaten this about 90 minutes before she died. This would time her death at about 9.30 p.m. to 10.00 p.m. when Harry was on his way to or at work.

*

Harry appeared at Lincolnshire Assizes in Lincoln before Mr Justice Denning on 25 October 1945.

Mr C. L. Henderson, KC, and Mr A. P. Marshall prosecuted, and Mr Arthur Ward, KC, and Mr W. K. Carter appeared for the defence.

Harry pleaded not guilty.

Mr Henderson made his opening speech but he said that a question arose in the case on which he thought he should address the Court, and he thought it should be done in the absence of the jury. He felt that the position of the Crown had been made difficult because of 'certain' evidence that had been presented. Mr Justice Denning said he had read the depositions and Mr Ward for the defence said that he should object 'most strongly' to the evidence in

question being given, and so agreed that the jury should be out of Court whilst the legal argument between counsel and the judge was considered.

The jury retired.

Mr Henderson said he had a report from the prison medical officer, which he had shown to the defence. This showed that Harry had an intelligence which was below average – the equivalent of a child of eleven years, three months.

Mr Ward had said that he proposed to object to the admissibility of DCI Davis' evidence. In his deposition to the Court, he stated that he had said to Harry:

'I should like you to make a few notes as to what you saw before I see you.'

This might have an effect, Mr Ward contended, on the accused which it would not have upon a normal adult.

So it came down to what the police felt was Harry's confession, but Mr Justice Denning ruled;

> ... that he was quite satisfied that the alleged confession ... flowed from hope or fear, excited by a person in authority (DCI Davis) and in those circumstances ... could not admit the alleged confession.

So with this and his pretty reliable alibi, and the absence of forensic evidence on any of his clothing, it was of no surprise that Harry was acquitted. One wonders that he was charged in the first place.

<center>*</center>

Thomas Henry (Harry) Ramshaw died in Scunthorpe in the summer of 1962, he was sixty-six. Although the case was re-opened, there were no further arrests for the murder of Miss Charlesworth.

But there are a couple of issues, and we will turn to Harry first. He left home for work at about 9.30 p.m. and was on the bus and with a colleague all night, it would have been impossible for him to have left the steel works without being missed, returned to the house – without being seen by any witnesses – strangled and then battered Miss Charlesworth – without getting any blood on his clothing and then return to work – behaving as his usual self. As already discussed, his alibi made this abundantly clear, yet he was arrested and charged. There is the possibility the Police thought he had committed the crime before he left for work; but the estimated time of death was between 10.00 p.m. and midnight, so this would not support that assertion. The back door was closed but not locked and the time was late September so it would be unlikely that any extreme of temperature would have confused the time of death. However, there is no record of a detailed examination of Miss Charlesworth at the scene of the crime, and estimating the time of death is just that, estimating. Harry would need to have a good grounding in physiology, get home by some means which would equal the speed of a bus, not be seen, dispose of his clothing

completely and then return to work behaving quite normally. Harry was not an intelligent man and it does not sound as though he was a cunning man – it certainly did not sound as though he was an evil man.

But the central question seems to be as to why, when manual strangulation had already rendered her unconscious, was she battered? Why use all of this energy and splatter forensic evidence all over the place? The answer seems to be that her assailant wanted to render Miss Charlesworth unrecognisable. And although this can never be confirmed, the question of why she was beaten to the degree that she was unrecognisable remains.

There is some mystery also that Harry had lived in the house for many years but the Police did not find any fingerprints belonging to him. The Police behaviour in this case seems confusing and it would be unfair to make assumptions, but there is the idea that Admiral Nelson deliberately held his telescope to his blind eye and said: 'I see no ships'.

Miss Charlesworth was sixty-nine years of age and single; she was active in the church and well known in the community. The idea of a mistaken identity does not seem to quite fit. The Police publicly said there was not a homicidal maniac on the loose, but privately believed there was. With such a weak case against a man with a strong alibi one wonders about the Scotland Yard officers, yet the Director of Public Prosecutions went ahead with the case.

Miss Charlesworth was identified by Harry and her niece by her build and her attire. There were several items of clothing which definitely belonged to her, found on the body. The clothing, no doubt, belonged to Emily Jane Charlesworth, and the body was found in the kitchen of the house where Emily Jane Charlesworth was housekeeper. So can there be any doubt but that it was the body of Emily Jane Charlesworth?

OSWALD WALKER, HULL, 1936

Twelve years to the day before Henry Warner was attacked in Leeds, Mr Oswald Fisher Walker was found murdered in his shop in George Street in the centre of Hull. He had been struck on the head a number of times with a blunt instrument. Sixty-eight-year-old Mr Walker ran a retail tool supply business and had done for many years. It seems that the 13 March is not a happy day for small businessmen in the north. But this time, almost before the doctors had pronounced Mr Walker dead, Hull City Police had formally asked Scotland Yard to oversee the investigation.

Mr Walker was married to Emily and active in his local church; he had remarried two years previously, his first wife Helen had died six years before. He had two grown-up children who were both married with families of their own. His daughter Ethel was forty and married to Mr Arthur Pattinson, and his son Norman was thirty-eight and married to Evelyn. Both families lived locally and there were grandchildren. Norman had at one time worked for his father but the two did not see eye to eye, and he had been sacked from his job. Norman had then started his own business in competition to his father, and took several of his father's customers and staff with him. Later he had bought out his father from the plant machinery side of the business. There was some respect from son to father, but although he acknowledged his father's generosity to church and charitable funds, he had long thought his father mean to his employees in that he paid them less than they deserved. Mr Walker senior employed four people at his shop.

It was at about 4.45 a.m. on Saturday, 14 March 1936, that Mr Thomas Howden, Chief Constable of Hull City Police made the telephone call to Whitehall 1212. He told the operator that at about 12.35 a.m., Mr Walker was found dead with his head battered in at the lockup shop, 29-31 George Street, in Hull. He is believed to have been robbed and the clothing of his attacker may be bloodstained. Mr Howden requested that they send a man up as soon as possible. In the meantime the Police in Hull would leave the

Left: Portrait of Oswald Walker.

Below: The Biarritz pub is of striking contrast to Mr Walker's original shop.

body and everything at the scene of the crime exactly as it was found until the Scotland Yard man arrived.

The request later found its way to Superintendent Arthur Askew. He called for Detective Chief Inspector John Sands and he was paired with Detective Sergeant Albert Griffin. The two detectives made arrangements to travel to Hull and also requested the expertise of Detective Inspector Frederick Cherrill, a fingerprint expert, and Detective Inspector James O'Brien, an expert at crime scene photography. The officers boarded a train at Kings Cross station in London at just after 10.00 a.m. on the Saturday morning.

They arrived at Hull in mid-afternoon and the head of the local CID, Detective Superintendent Michael Mulchinock, was at the station to meet them. They were taken to Hull City Police Headquarters, where they met and discussed the case with Mr Howden. The Scotland Yard men were briefed of the arrangements and the assistance they were to be given.

At just before 3.00 p.m. the group of officers went to the scene of the crime at 29-31 George Street; George Street was a main and busy thoroughfare. They were shown to the rear of the premises where the crime scene had been preserved. The local Police Surgeon, Dr John Cumming, had made a brief examination of Mr Walker earlier that morning and now joined the detectives at the scene.

The premises was a single-storey building and a workshop stretched back from the shop at the front. Altogether the premises were nearly a hundred feet from front to back, but only about nine feet wide. Down each side of the workshop were racks, shelves and cupboards; above were skylights and the attic space was open. The rear of the workshop opened onto New Garden Street which was at a different level, so at the rear of the workshop there was a flight of six stairs down. Just before the stairs there was a doorway leading to the second workshop which ran parallel with the first. It too had a rear access door and Mr Walker would keep his work car garaged there. Immediately inside the door leading from the first workshop was a small platform/landing with two flights of stairs leading down from the platform/landing which was about five feet square. It was partly on this platform, with his legs lying on the stairs, that Mr Walker was found.

He was fully dressed and had his overcoat on, though his hat was later found in his office. Mr Walker was lying on his back, and his feet were overhanging the second of the steps with his head nearest the door.

There were a number of head injuries, which were caused by a succession of what were described as savage blows on the head with a blunt instrument. Mr Walker's upper right arm had also received a heavy blow. Although the wounds on the head would have bled profusely, there was surprisingly little blood or blood splashes on the surrounding objects. Blood had drained from Mr Walker's head through the planks of the platform/landing and had dripped onto the floor below, creating a fairly large pool of blood.

Mr Walker was wearing a heavy gold watch and chain – which was quite visible – when found, his overcoat and jacket were unbuttoned and open. There

was also a black wallet which contained £3 that was made up of ten shilling notes. The wallet was clear to see and was protruding from Mr Walker's inside jacket pocket. It was thought he had been smoking his pipe when he was attacked because debris was sprinkled liberally around. Mr Walker was also struck on the chin which may have been by implement or fist, his dentures had become dislodged and were broken on the floor around and underneath his body. His spectacles had been dislodged also.

In 1936 the whole idea of 'Scene of Crimes officers' was in its pre-embryonic days, but expertise was building up, and the two specialists who accompanied DCI Sands and DS Griffin to Hull could now get to work. DI O'Brien took a series of photographs of the scene of the crime with Mr Walker left where he had fallen. DI Cherrill began a determined and painstaking search for fingerprints; he was to work for many hours tirelessly until he felt he had collected all the fingerprints the scene and surroundings had to offer. DI Cherrill worked through the night and on through to the Sunday afternoon, the 15 March. Unfortunately, the only fingerprints were found on a saw bench, which was a machine to feature prominently in the case and will be returned to, and the fingerprints he found were actually those of Mr Walker.

Of course, the local CID officers gave all the help they could, and finding the murder weapon could give a great deal of information: the search went on for this for the best part of a week as the Police continued their examination of the premises. But the search for the weapon did not meet with any success, which was mainly due to the business Mr Walker was in, that of tool merchant, so there were literally hundreds of implements in the workshop. Mallets, axes and iron tools, all or many of which were capable of having inflicted the wounds on Mr Walker's head. All of the possible murder weapons were minutely examined, but the weapon could not be identified.

Late on the Saturday afternoon (14 March), Mr Walker's body was removed to the City Mortuary. It was now possible for DCI Sands to make a thorough examination of the clothing, but again the search produced nothing of any great value to the enquiry. He found that Mr Walker was carrying 13/6½d. in cash, keys, tobacco and pouch, a diary, silver cigarette case, railway season ticket, four handkerchiefs, gloves, penknife, matches and other personal effects. This together with the presence of the wallet and gold watch and chain did cast some doubt over robbery as a motive.

At 11.00 a.m. the following day, Sunday 15 March, a post-mortem examination was carried out at Hull City Mortuary by Dr Wallace Adamson, in the presence of Dr Cumming, and some of the senior police officers – Supt Mulchinock and DCI Sands included.

Dr Adamson reported that 'the deceased' was a healthy well-nourished man of sixty-eight years. The cause of death was fracture of the skull, contusion of the brain with haemorrhage from the vessels of the skull, asphyxia and shock. But there were also some small marks around the front of Mr Walker's neck which gave the appearance of '... ligatures having been tied round the neck ...

(but) ... little sign at the back.' The markings seemed to correspond in pattern and outline with the shirt he was wearing.

The inquest was opened on Thursday 19 March. The coroner, Dr Norman Jennings, enquired if the wounds showed from what angle Mr Walker had been attacked; Dr Adamson explained that the wounds were inflicted, he thought, when 'the deceased' was on his back. In Dr Adamson's opinion, the head wounds were inflicted after he had been partially strangled. The injury to the jaw, he said, could have been inflicted by a fist or by the end of a blunt instrument, and he explained that considerable violence had been used. Dr Adamson also stated that the wounds were caused by a blunt instrument, which would probably be pointed at one end because one portion of the wound had been circular.

Mr Walker's widow gave evidence which established identity. In order that the Police could continue their investigation, the inquest was adjourned until 13 May 1936.

DCI Sands thought that with consideration as to the position of the body when found, and the injuries sustained, that it was more likely Mr Walker had been attacked from behind as he descended the short flight of stairs which led to the rear of the workshop. The neck injuries were much more difficult to explain but one possibility was that the assailant had gripped Mr Walker's collar and jerked him backwards. This idea does have some supporting facts insofar as there were no strangulation marks at the back of his neck; the other injuries could possibly have been caused as he was falling or alternatively if he was pulled up into a sitting position. It was less likely that the injuries that led to the bruising on the front of the neck were inflicted while he was lying on his back.

The Police Surgeon, Dr Cumming, was in agreement with this, but he thought it possible that two men had attacked Mr Walker. There also seemed general agreement that the attack had been sudden as Mr Walker was wearing glasses and had seemed to have been smoking his pipe, or at any rate the pipe was in his mouth at the time of the attack. The broken stem of the pipe, some parts of his glasses, and his bottom set of dentures were found under the body. A tooth was also found on the first step down, and parts of the broken glasses and the bowl of his pipe were scattered several yards away.

The workshop was reluctant to yield any clues, but one possible clue which resulted from the examination of the premises was a part of a patterned footprint on the bottom step of the set of six, and it was not Mr Walker's footprint.

So there were not a lot of leads found by DCI Sands in the early stages of the investigation. He re-read the reports as to the discovery of the body. But he also carefully considered the members of Mr Walker's family.

*

Mr Walker's first wife, Helen, had died in October 1930. But Mr Walker had married Emily in March 1934. The two children by his first wife, Norman aged thirty-eight, and married to Evelyn with two children, and Ethel, now Mrs Pattison, forty, both still lived in Hull and were in close contact. They seemed to have accepted their father's remarriage and there appeared to be little or no noticeable tension between Mrs Walker and Mr Walker's son and daughter.

On the evening of the 13 March, Mrs Walker became concerned that her husband had not returned home from work and so decided she should make contact with the Police shortly after midnight. Mr and Mrs Walker lived about twenty miles from Hull in the small seaside town of Hornsea. Hull City Police responded to Mrs Walker's call – a call was put through to the Worship Street Fire Station and at about 12.15 a.m. in the early morning of 14 March, PC Charles Winterbotham went to Mr Warner's shop. Initially it was thought that he had had an accident.

PC Winterbotham found that the shop door and also the door at the rear of the premises were secure, and he could not see any lights on in the shop or workshop, so he returned to the Fire Station to contact the Police Station. Meanwhile, Mr Walker's son and son-in-law had arrived, so PC Winterbotham returned to the shop with the two men. They also secured the services of Mr Benjamin Jones who was a fireman. It was found that the George Street door that led to the shop was only latched and not securely locked as would be usual, so Mr Norman Walker suggested they force the door. Mr Jones did so and the four men entered the front part of the premises. The lights were switched on and there was little to show there had been any disturbance in the shop or workshop. Whilst Norman Walker found the light switch, PC Winterbotham made his way to the rear of the workshop: and so discovered the body of Mr Walker. He went back to the others and explained what he had found. He was reluctant to let the two men see the body in the interests of the preservation of the crime scene; in the event Mr Pattison saw the body but Norman preferred not to.

Some suspicion was to fall on Norman Walker in the early stages of the investigation, particularly as he had not been on very good terms with his father and had latterly become a business rival. However, the Police were able to rule him out quite early on; he had been quite open and honest about his relationship with his father both socially and business wise. Mr Warner's first wife, Norman's mother, had been a good, calming influence between the two men when they had their differences but when she died this did create a vulnerability between them for ill-feeling.

PC Winterbotham made contact straight away with Police Headquarters and senior officers attended. Dr Cumming was summoned at 1.00 a.m. and he attended soon after. He thought Mr Walker was dead so did not do too much that might disturb the body. He quickly found that rigor mortis had set in; in Dr Cumming's opinion, death had taken place four to five hours previously, which would fix the time of death at between 8.00 p.m. and 9.00 p.m. the previous evening, 13 March.

*

Mr Walker had employed four people at his George Street shop. They were a Miss Jessie Walker, who was twenty (she was no relation to Mr Walker); she looked after the admin side of things; a Mr Leonard Houldridge, who was thirty-five and was a saw repairer; William Ernest Davies, aged twenty, who was a shop assistant, and an errand boy named John Kay, who was fifteen.

There were two sets of keys to the front shop door, one set was held by Mr Walker and the other by the shop assistant, Mr Davies. The usual routine had been that Mr Davis opened up the shop each morning prior to the arrival of Mr Walker. Both sets of keys were accounted for. As far as the Police could make out, there was only one key to the rear door of the top workshop and this was usually left in the lock by Mr Kay. There had previously been another key which was stolen in November 1935 by two local lads, William Shearer and Thomas Markham, both aged fourteen, who admitted breaking into the shop on a number of occasions. At the time of the murder, William Shearer was detained in the Castle Howard Approved School. His partner in crime, Mr Markham, stated that this stolen key was subsequently thrown away. The doors of the bottom workshop were secured from the inside with a bar and padlock and the key was found in the usual hiding place in the top workshop.

But the Police discovered that the key to the top workshop, which had been left in the lock of the rear door by Mr Kay when he had locked up, was missing, and the iron bar which he had placed against the door had been moved. It was thought therefore that the murderer had left the premises by that door, locked it behind him and took the key.

Whatever might have been the motive for this murder, it was quite clear to DCI Sands that the body was not properly searched because of the wallet and cash found on Mr Walker's person. At that stage though, the Police were unaware that Mr Walker had another wallet, and this was unaccounted for.

It was thought early on that the culprit suddenly became anxious after the murder and so made a hasty departure before any consideration of robbing Mr Walker. But the lights were all turned off between the shop and the lower workshop. And also the murderer had locked the rear door he was thought to have made his escape by.

The staff all made statements. Miss Walker said she left the shop at her usual time of 5.00 p.m. on 13 March, and when she left she knew the three other employees as well as Mr Walker were still on the premises. At 6.00 p.m. Mr Kay locked the rear door – but he left the key in the lock and placed an iron bar up against the door, he said he did not bolt the door at the bottom – though he usually did – but had been quite sure that the door was secure. He then left the shop for the night. Mr Davies and Mr Houldridge left together soon after. When they left they said that Mr Walker was in his office, which is between the shop and the George Street end of the top workshop. The shop door in George Street, which is fitted with a Yale and box lock, was left open.

In fact, a few customers came to the shop and were served by Mr Walker between 6.00 p.m. and 7.15 p.m., the last was a Mr Edward Hancock, who said he went to the shop at about 7.05 p.m., and at this point the door was latched. He rattled on the door, which was soon opened by a youth, Walter Bousfield, and he entered the shop. Inside were Mr Walker and two other customers – Mr Bousfield who bought a claw hammer and a Mr Walter Fearnley, who wished to purchase a bricklayer's hod. These two customers left the shop with their goods which left Mr Hancock in the shop, but he departed soon after, this being about 7.15 p.m. Mr Hancock said the only person then left in the shop so far as he was aware was Mr Walker, and he was quite definite that the shop door latch was dropped and it closed behind him. Mr Walker was by then dressed in his overcoat, apparently ready to leave the premises.

The Police checked the statements from each member of Mr Walker's staff. All of their movements and activities on the evening of 13 March were corroborated.

DCI Sands recorded the observation that '... Mr Walker senior was a man of unusual habits.' He was an ardent Methodist and was noted for his generosity with religious charities, but in his business dealings and in his employees' wages he was considered mean. He paid his employees less than was usual – actually Norman often 'topped up' their pay. And Mr Warner senior would seldom confide his financial details to anyone, so subsequently when he died no one knew of his arrangements.

Mr Walker was considered as old-fashioned in his business methods, whereas Norman was a keen businessman with up-to-date ideas and was more ambitious in his business acumen. Norman occasionally suggested certain deals to his father, who often would not even consider them. There were times when Norman carried these deals through on his own and then decided to keep the profits. This led the father to accuse Norman of pocketing profits from the business and there were said to be frequent arguments between them. Norman, with an eye to the future, had occasionally approached his father with a view of receiving a partnership or controlling interest in the business, but his father would not even consider this, mainly due to the differences in their business methods. Their relationship continued to deteriorate and things came to a head between them in July 1935, when the father gave Norman a week's notice to terminate his employment. Norman worked out the week's notice, during which period he completed one or two jobs he had in hand, and he then opened a tool merchant's business in Silvester Street, which was only two streets away, in opposition to his father. Norman's business was quickly a success and he took a good percentage of his father's customers, as well as his manager and errand boy with him.

Strangely this did not create more ill-feeling between the two of them, if the deteriorating relationship did not tend to plateau then it actually improved. Mr Walker senior advertised the Anlaby Yard business for sale, and after protracted negotiations by solicitors lasting well over two months, Norman purchased it for £650. He arranged to pay by quarterly instalments of £26.

Overall, the two 'rivals' would help each other in business and refer customers to each other if they could not help them. Mr Walker senior would often visit Norman in the Anlaby Yard, though it is not clear whether he ever visited the Silvester Street shop. For his part, Norman did not ever visit the George Street shop until the night of the murder.

Norman explained this in depth to DCI Sands and the fact that their personal relationship remained strained.

It is not clear as to whether Norman knew of his father's will arrangements or not, and these changed on several occasions following the death of his first wife and up to the time of his own death; DCI Sands thought this indicated the '... widening gulf' between the two. Initially he had bequeathed his son one third of his entire estate; this had changed and in his most recent will he left Norman a gold watch and chain.

Some years previously, at the time of his marriage, Norman's father gave him the freehold gift of a house, where he had still lived, as a wedding present.

The last time Norman saw his father was, he said, a fortnight before the murder. As to the evening of 13 March, he could account for his movements in detail which were all verified as a matter of course. DCI Sands was to later record that he was completely satisfied that Norman Walker was not connected in any way with his father's murder.

<p style="text-align:center">*</p>

Mr Walker did not keep accurate or even adequate records of his business affairs and no records at all were kept of his over-the-counter sales. Any money was just placed in the till with no record of what was sold or to whom. At the end of each day's business he would clear all the money from the tills, minding to replace the 'float' in each (£1 in silver in one and 10/- in small silver in the other). The total of what he cleared, minus the next day's 'float' would be recorded, but only in a small notebook he kept himself. This created a problem for the Police as they wanted to know who had been to the shop in the period before Mr Walker met his death. However, the Police were able to establish that he had finished this routine on the night before the fateful event.

The tills were actually only wooden drawers which fitted under the counter and each night they would be removed and stored discretely in the office behind the shop. When the Police investigated they found the tills were where they were supposed to be. Also hidden in the office was a cashbox and in this Mr Walker would keep money that accumulated from the cash sales.

This cash box was always kept locked and only Mr Walker held the key. Money from this cash box was not usually deposited in the bank, unless it accumulated to about £15, but again no record was kept of the cash in the box or its balances. But the box was found intact with just over £3 and some personal papers in it. It was locked and in its usual hiding place.

Mr Walker would usually carry two wallets on his person, of which one was for business use and the other for personal. One of the wallets was actually found in his jacket pocket after his death; this was black and it contained six 10/- notes. Miss Walker was able to identify this wallet as the one her employer used for business purposes. That afternoon, the staff had been paid and the bulk of the wages were made up of 10/- notes, which Miss Walker said he had taken from his business wallet. Another old, torn and dirty wallet was found in the locked cash box. His wife had been able to tell the detectives that the wallet they found in the locked cash box was not the wallet he usually used for his personal use. She would frequently see this wallet and every Friday he would give her £5 for the weekly housekeeping from money he kept in his personal wallet. It was said that Mr Walker would sometimes have as much as £20 in this wallet. As this wallet was not discovered on his person then it was assumed it had been stolen by his murderer, which tended to suggest that robbery was the main motive for the crime.

But money was not the only thing Mr Walker kept in this wallet. It also contained his driving licence, some correspondence and photographs. It was fairly bulky, and it did not prove easy for DCI Sands to get a good description of it. Mrs Warner had done what she thought was her best to help and a man Mr Walker often travelled with, Mr Frederick Carrick, agreed the wallet was either black or very dark; it was also said to be embossed with the name of a firm of toolmakers from Sheffield, but no further details were known.

It was not unusual for Mr Walker to stay behind in the shop after business hours and after his staff had gone home, and this happened too on the evening of the murder. This was to keep a business appointment that had been made, but there was no record as to who the customer was. This was the one clue the Police thought could lead them to the killer. Apparently a customer had made enquiries about a saw bench, and it had been on a saw bench that fingerprints had been found.

And there are a few facts about this appointment that are worth considering. Mr Davies, the shop assistant, told the Police that at about 8.30 p.m. on 7 March, which was the Saturday before the murder, Mr Walker had told him that it was time he put up the blinds outside. Mr Walker had said to him:

'I don't expect there'll be many more customers now.'

There had not been any customers in the shop at that time so Mr Davies had started to put up the blinds. However, after he had put up the first blind and had gone back into the shop to get another, he saw Mr Walker was serving a customer. After he had put up the second blind, Mr Davies noted that there were another three customers in the shop. Mr Walker was attending to two of these, a Mr Edward Pease and his wife, Emma. So Mr Davies approached the other customer to serve him, as he approached him he said:

'Yes, sir?' The man said: 'Mr Walker' at the same time pointing to him, Mr Davies took this to mean that the customer wished to be served by Mr Walker so Mr Davies walked behind the shop counter. As he did so the first

two customers left the shop. DCI Sands uses an interesting phrase to describe the next part of Mr Davies' statement:

'Mr Walker then attended to the *suspect*.' [Author's italics.]

Following on from this, Mr Davies attended to some other duties – he switched off the electric fire, motor and window lights – which was when he saw the man with Mr Walker in the office. They were talking about a saw bench, and he heard the man say that one was too big and the other in the workshop was not big enough. He did not hear any further conversation and he waited in the top workshop. Mr Davies said that the man left at about 8.40 p.m. and, as he was leaving, Mr Davies heard the man say: 'I'll call and see you later.'

Mr Davies described him as aged about thirty-six or thirty-seven years, 5 feet 8 inches, tall, dark complexion, dark hair, clean shaven, round chin, round face, slightly scowling, unkempt dirty hands, medium build, dressed in working-class dark-coloured clothing, dirty grey cap, and he believed he was wearing a dirty mackintosh with a belt. This is an incredibly detailed description, so one wonders if there were reasons Mr Davies noted this amount of detail, especially when comparing this description with that of the other customers who attended the shop at the same time.

The Police traced and interviewed the other customers who had been in the shop: Mr Pease and his wife remember seeing this man. But Mr Pease could not describe him at all and Mrs Pease's description of him was vague: she had no idea as to his age, having only seen the back of him, but said he was about two inches shorter than her husband, who was 5 feet 8 inches, and that he was wearing a light-fawn raincoat or mackintosh, but she did not think it had a belt.

Two other customers who were in the shop at about the same time, Mr Louis Medforth and Mr Frank Morgate, were also interviewed. But they could not give any information about him.

DCI Sands made this observation:

'What it amounts to is that Davies is the one and only person who can describe the man we suspect and he is doubtful if he could identify him.' The fact he said Mr Davies later doubted that he could identify suggests that Mr Davies was questioned closely about him.

*

It was his usual routine for Mr Walker to arrive home from work at around 7.00 p.m. on weekdays, except Thursdays and Saturdays. But on Wednesday 11 March, he did not arrive home until 8.00 p.m. He told his wife he had been kept talking at the shop with a man who had called to buy some machinery; but the man did not buy any thing at that time and was coming for a second viewing. DCI Sands thought there was little doubt that it was the customer enquiring about the saw bench.

When leaving home on the following morning, which was Thursday, Mr Walker told his wife he would not be home as usual at 5.30 p.m. that evening as he wanted to go to Anlaby to collect a debt. During the journey into Hull that morning, Mr Carrick, who usually travelled with him, said that Mr Walker stated he had to stay later at the shop the previous night to meet a customer for tools.

At about 12.30 p.m. that day (Thursday 12 March) Mr Walker said to Mr Davies:

'A gentleman has been in, he kept me talking last night about the saw bench until about twenty minutes past six and never came to an agreement and said he was coming in again Friday next about six o'clock.'

It is likely that Mr Walker was anticipating the sale of the saw bench for that day so he sent the errand boy to a local firm for materials with which he constructed a drive-shaft for the machine. He was working on the saw bench all that afternoon.

When Mr Houldridge, the saw repairer, noticed Mr Walker working on the saw bench he said to him:

'Have you sold that saw bench, Mr Walker?' Mr Walker replied:

'Yes, a chap at Beverley is coming to see me tonight and it will be late again before I get home. He came the other night and spent twenty minutes looking at the jolly thing. I've not got paid for it yet, you know what these country fellows are, tight fisted persons. It takes a lot to get money out of these jokers.'

This was the first time Mr Houldridge heard that there had been an enquiry for the saw bench and in the conversation Mr Walker told him that the man could not get to the shop in business hours because he had to come from Beverley, where he worked.

It was thought by the detectives that Mr Walker may well have had an appointment with the man on the evening of Thursday 12 March and so they checked his movements for that afternoon and evening as much as they could.

They found that Mr Walker had left the shop at 4.30 p.m. and his movements were recorded up to about 5.45 p.m., when he was last seen in the Cecil Cinema Café. He arrived home at 10.00 p.m., but it is not known where Mr Walker was between 5.45 p.m. and 9.05 p.m. DCI Sands thought he had later caught a train from Hull to Hornsea, which was his usual routine.

On the following morning (Friday 13), the day of the murder, he handed Miss Walker three letters, two of which were requests for payment of outstanding accounts. Miss Walker said that as she was handed the letters, Mr Walker mentioned that he had called on one of the customers to collect the money owed. She does not know which one Mr Walker was referring to, but had some recollection that he said he had called on them the previous evening, and that Mr Walker had said his customer was not at home, but he did see the lady of the house. However, she recalls he had said that by the time this happened it was after 6.30 p.m. and so he decided not to call back at the address.

One of the customers was a Mr Walter Hall who had made a purchase from Mr Walker in the previous summer and was in debt to the sum of £1 9s 10d. Mr Walker had been reluctant to let this debt continue unpaid. He had called on this customer but had not recovered the debt: Mr Hall explained to the Police that he had found one of Mr Walker's calling cards on his mantelpiece; he said he did not remember picking the card up from his front door but it must have been delivered by hand as it was not stamped. Mr Hall and his wife had been out from 5.45 p.m. until 9.00 p.m. on the Thursday evening (12 March). From the centre of Hull, it would take about 15 minutes to reach Mr Hall's address, so it was thought possible that Mr Walker went there after he left the Cinema Café early on the Thursday evening.

As Mr Walker knew his wife planned to attend a church social function on that Thursday evening, it is quite possible he took this opportunity to call on customers to remind them of their outstanding debts. Although a calling card was evidently left at Mr Hall's address, this debt was many months old, and it does not seem, as DCI Sands asserted, that this was part of what he described as Mr Walker's 'mean' nature. And as Mr Walker was also happy to remain in the shop after his staff had left and other shops had closed in the hope of attracting business, no matter how small, it may be that he simply had his 'accounts' to attend to but would attend to a late-visiting customer. It may be he was happy to help as much as making extra profit.

On Friday 13 March, he left home as usual in the morning and he had told his wife that he would be late that evening as the man who had visited his shop on Wednesday was calling again. He also mentioned this to Mr Carrick on the journey into Hull. Mr Carrick was of the impression that the Wednesday and Friday visits were not connected with the business of the Thursday, although he said he had a vague recollection that Mr Walker said he had an appointment after business hours on the Thursday in connection with a machine. It does sound as though it was just time-passing chatter between the men and, for instance, the actual business of the man who called about the saw bench did not seem to come up.

At about 10.00 a.m. that morning, Mr Walker left the shop in his car, which he usually kept in the garage in the lower workshop, to deliver a bath he had repaired for his daughter, Mrs Pattison. She lived with her husband in Anlaby Park Road and Mr Walker was only away from the shop for two hours. From the time he got back until about 1.00 p.m. he had stayed in the shop. He went out to lunch at 1.00 p.m. and met his daughter at Hammonds Café. They were in company with a Mr David Toyne and a Mr Harry Clarke; Mr Toyne said later that Mr Walker had casually mentioned over lunch that he would not be going home at his usual time as a customer was coming late to the shop.

But it does seem as though the customer who was coming that evening had taken the enquiry into the purchase of the saw bench to a fairly advanced stage as Mr Walker was preparing an account for him. After lunch that day,

Mr Walker gave Mr Davies a slip of paper to take up to Miss Walker for the account to be typed. Mr Walker had said:

'It's for £30-5-6d and if he buys the lot I shall give him back the 5/6d.' DCI Sands was certain this related to the saw bench.

Unfortunately no name or address for the customer was recorded; Miss Walker typed out the invoice: 'One circular saw bench and one second-hand circular saw.' The prices were also detailed, the total being £30 5s 6d.

Miss Walker said she had actually asked Mr Walker for the name and other details of the customer but he said he did not know. Mr Davies returned the invoice to Mr Walker who put it in a plain envelope, unaddressed and unsealed, and placed it on the side of his desk. But it seemed this was not unusual for the way Mr Walker conducted his business, Mr Davies said that often customers' names were not noted until a receipt of purchase was issued.

Following on from this, the shop and workshop seemed to have a quite typical afternoon: Miss Walker said she left the shop at 5.00 p.m., and the rest of the staff left at their usual time of about 6.00 p.m. It is uncertain who came to the shop after this, but the Police were able to record the last known person to see Mr Walker alive (apart from his killer or killers) as Mr Hancock, who bought a spirit level bulb and left the shop at about 7.15 p.m. Mr Hancock said that when he left the shop the door had latched behind him and he was quite sure the door was locked. He also said he saw no one in George Street who appeared to be loitering or acting in any suspicious way. But he did note some cars parked outside the shop; he had gone to the shop by motorcycle. Mr Walker had at that time (7.15 p.m.) been wearing his overcoat.

When the crime was later discovered, Mr Walker's hat, with a newspaper folded underneath, was on the front of his desk as though he had been ready to leave. But the invoice for the saw bench, which Miss Walker had prepared earlier that afternoon, could not be found. Therefore, the customer known as the 'saw bench man' became a definite focus for the enquiry.

The saw bench was quite a common tool and was regularly a tool owned and used by both timber merchants and firewood dealers. So it was decided that the inquiry should seek to identify and investigate those types of businesses in the area. The Police covered distinct areas. DS Griffin liaising with Supt Mulchinock searched and followed up all leads from the Beverley area, whilst in the City of Hull the local CID officers and Police on beat duty would interview timber merchants and firewood dealers. All businesses were visited and interviews were conducted but with disappointing results.

It was therefore considered possible that the whole of the saw bench issue was merely a diversion and a way of keeping Mr Walker on the premises after his staff had left and trading for the day had (finally) finished. It was also remembered that the machine itself was in the rear of the premises which would take the 'customer' and Mr Walker away from the front of the shop.

DCI Sands and his colleagues felt quite confident that the murderer had left the premises through the back door which opened onto New Garden Street

because the back door key was missing and an iron bar which had been placed as a wedge to keep the door closed had been removed.

Mr Davies had given the Police a detailed description of the man earlier so this was widely circulated in the Press. It was also featured heavily in the *Police Gazette* and in the East Riding Informations (a pool of information circulated between the various Police 'forces' in the area). Also, the local Press was helpful and requests for information were published. In the Hull Cinema, from time to time, information on the murder was given in the hope this would jog memories. The Police mainly wanted to know the movements of Mr Walker on the Thursday (the day prior to the murder) and also Friday 13 March. But the Police did leave matters open-ended, requesting other information which members of the public thought would help. Mr Walker's customers for the two days also received a plea to come forward, and especially a request for anyone who had visited the shop on the evenings of 7, 11 and 13 March.

The public responded well and a number of people came forward and described suspicious behaviour or occurrences in George Street on the evening of the murder. Each line of enquiry was followed up.

At about 5.55 p.m., Mr Joseph Lorrimar, who was a bus driver for the Hull City Corporation, was driving through George Street. He said he saw a man standing well back on the pavement and on the opposite side of the street to Mr Walker's shop. The man was staring quite intently at the shop. But what made Mr Lorrimar even more suspicious was when he returned to George Street a good hour and a half later, the man was still there. This would have been far too long for him to be waiting for a bus or to meet someone. So Mr Lorrimar took particular notice, and he looked across the road himself to try and see what the man was staring at. He gave the Police a description of the man and DCI Sands was quoted to have said that the man: '... somewhat answers that of the saw bench suspect.'

Directly opposite the front entrance to the shop was the Princes Hall Cinema. At 7.25 p.m., Mr George Hewitt, who was an usher there, was collecting tickets from customers when he saw a man enter Mr Walker's shop. He said that the lights were on in the shop and he was certain of the time because he did not start work until 7.20 p.m. Mr Hewitt continued with his work and about half an hour later he saw a woman at the shop door. By then the shop was in darkness; but the woman was kicking the door with her left foot at the same time looking through the glass panel in the door and trying the door handle. No one opened the door and the woman walked away after a few minutes. Mr Hewitt's attention was first attracted to the woman by the noise she made in kicking the door. As for the man – he describes him as wearing a khaki overall coat, but in the darkness this could possibly have been mistaken for the mackintosh the 'saw bench man' had worn. An appeal was made in the Press for the woman to come forward, The description Mr Hewitt gave of her behaviour in that she was kicking the door does seem strange: if it had been a builder urgently wanting a new tool then it might have been understandable,

but in those days women would not generally have the need for working tools. The door kicking does make it confusing and one wonders if the matter had been straightforward then why didn't she come forward. But there does not seem to be any mention of a description for this woman.

Then, at about 7.30 p.m., Mr Charles Holtby was passing the shop. He noticed a man standing in the doorway of Mr Walker's shop, facing out onto the street. Mr Holtby thought initially that he recognised the man as a friend he had known several years before and walked towards him, but the man was not who he thought he was. Nevertheless he did pass closely by and could give the Police a description of the man, which corresponded with the 'saw bench man'. After a few minutes he saw the man leave the doorway and get into a car, which had been parked outside the New Manchester Hotel, a few yards from the shop. Mr Holtby described the car as an Overland 4-seater tourer, with no hood, a 1926 model or earlier and painted a dark colour. But the car was in a dilapidated condition and Mr Holtby said he could not read the registration number. He added in his statement that the man seemed quite leisurely in his manner.

Exhaustive efforts were made to try and trace the car. Appeals were made through both the local and the national Press, but no information which could have led to the identification of the car, and therefore its driver, was forthcoming.

At about 7.55 p.m., Mrs Emily Buckley saw a man who was thought to answer the description of the 'saw bench man' and he was wearing a fawn-coloured raincoat; she saw him standing on the pavement outside Mr Walker's shop. Mrs Buckley thought the man was looking towards a car which was stationary in the kerb. Her description of the car was similar to that of Mr Holtby's, though she thought it was a different model. She came past the shop again a little later and saw the car was still in the same position but could not see the man. She did not notice any lights on in the shop.

If the Police Surgeon, Dr Cumming, had been correct in his estimation of the time of Mr Walker's death then it would have occurred roughly between 8.00 p.m. and 9.00 p.m. So when Mr Holtby and Mrs Buckley saw the man in George Street, Mr Walker had not yet been attacked.

At about 8.00 p.m. Mr George Newall was in George Street and he actually stopped and looked in the window of Mr Walker's shop. He said there were no lights on in the windows, and he had looked through the glass panel of the door also. Mr Newall was looking for fretwork sets so did look quite closely. He said he saw a light in the shop but it was towards the rear of the building on the left side, but even though he looked into the shop he did not see anyone moving around and did not hear any noises.

It is well to bear in mind that with the nature of the attack it is possible that blood had spattered onto the attacker. None of the witnesses who saw the man, who may have been the man known as the 'saw bench man' in George Street that night reported seeing any blood on his clothing.

At 8.20 p.m., Mr Herbert Walters passed the shop and saw a smartly dressed man standing in the shop doorway with his back to the door. He again passed the shop at 9.20 p.m. and the same man was still there. Although this is unusual it does not sound as though it was the behaviour of anyone linked with anything other than an innocent coincidence. If the Police had been right about the way the attacker left the shop, that is out of the back door and then locking it behind him, then it seems inexplicable the same man would then walk around to the front of the shop and stand in the doorway. And if the time of death was between 8.00 p.m. and 9.00 p.m. and Mr Walters saw the man at 9.20 p.m. then a bizarre delay in leaving the scene is apparent.

Mr Thomas Webster passed the shop at about 8.25 p.m. He said he had been walking slowly and had glanced into the shop as he passed. Mr Webster said he saw two men standing inside the shop; they were opposite the door and facing the door. There was at that time a 'bright' light in the shop though the shop window lights were out. Mr Webster described the two men he saw, and one was almost certainly that of Mr Walker, but he did not get a good look at the other man. But he did say the other man was about fifty years of age and about 5 feet 10 inches tall. One of the men was wearing a dark overcoat similar to the one worn by Mr Walker, but he cannot remember which one. The other was wearing a greyish khaki-coloured raincoat. It appeared that they were talking but Mr Webster could not hear their voices.

At about 10.00 p.m., Mr Henry Packer saw a man who was aged between about thirty and forty years, 5 feet 8 inches tall, of medium build, dressed in a loose-fitting, fawn-coloured mackintosh. Mr Packer said the man was standing in the shop doorway with his back to the street. The shop was now in darkness and he thought the man was just closing up the shop. By 10.00 p.m., Mr Walker may have been dead for a while, and again this does not fit with the main theory of the escape being made through the back door.

In the 1930s, hats were in fashion for men and it was unusual to see a man without a hat. So it is of no surprise that head-gear is commented on in the statements of the witnesses. This seems to give an opportunity to discuss the various descriptions of who the Police thought likely to be the 'saw bench man' and compare what they described him wearing on his head. Mr Davies described a grey cap, Mr Lorrimar described a grey checked cap, Mr Hewitt did not describe any hat, Mr Holtby said he wore a black bowler hat, Mrs Buckley said he was wearing a grey tweed cap, and Mr Walters said it was a grey trilby. Mr Webster described a 'hard hat', which in a later statement became either a bowler or a trilby. Mr Packer did not comment.

Unfortunately all of this confuses rather than clarifies. Mr Davies, the shop assistant, did not see the man outside the shop on the evening of the murder; he saw the man in the shop on a previous occasion. Of the seven people who saw the man in or around the shop on the night of the murder, two said he did not wear a hat, two said he wore a cap, one said he wore a bowler and one saw a trilby. And Mr Webster said he wore either a bowler or a trilby. Mr Davies actually saw

a man in the shop discussing the purchase of a saw bench with Mr Walker and he wore a cap; however, this is not supported by Mr Lorrimar and Mrs Buckley who both saw a man wearing a cap on the night of the murder, but they saw the man *outside* of the shop. Mr Webster saw a man *inside* the shop wearing a bowler or a trilby talking to a man without a hat on – Mr Walker's hat was found in his office as he had not put it on. So if Mr Walker had not put his hat on when seen by Mr Webster then the other man inside the shop is worthy of consideration: Mr Webster described him as about sixty years of age and about 5 feet tall – how did that compare with the description by Mr Davies of the 'saw bench man'? Well, he said this man was between thirty-six and thirty-seven and about 5 feet 8 inches. tall.

<p style="text-align:center">*</p>

All lodging houses and hotels in the area were checked for likely candidates but without success. Any known criminals in the area, especially those who had a history of violence were interviewed, but this did not take the investigation anywhere. Police officers who had been on duty in the city centre on the night of the murder did not report anything suspicious or out of the ordinary in George Street or in the surrounding streets.

There were quite a lot of events witnessed by people who were to come forward, but still the investigation hadn't a firm name on which to concentrate.

Hull was actually the third largest seaport in England at that time – it had seven miles of docks. Enquiries were made amongst seamen and at shipping companies, but no vital information was forthcoming.

Enquiries were also made to trace any criminals and other likely persons who left the area at about the time of the murder. A number of people were traced in London and other towns, but they all seemed to be able to account for their movements and whereabouts at the material times. Two criminals, however, who had left Hull, could not be traced for a considerable time, but one of them, named Kelleher, was eventually found.

Thomas Kelleher, a seaman and native of Cork, Ireland, obtained 8/- from the Hull Public Assistance Committee on the day of the murder and was due to receive a further sum on 13 March, but he failed to turn up to claim it. It is known that he stayed in a lodging house in Hull on the night of 14 March, the day after the murder, but after that he could not be traced. Mr Kelleher was well known to the Police and had previous convictions. His details were circulated in the *Police Gazette* and East Riding Informations, with the request that he be interrogated as to his movements on the evening of the murder. When he was traced and made a statement as to his movements on the night of 13 March, it was found he was not in the vicinity of Mr Walker's shop, so he was eliminated from the enquiry.

The other man proved far more difficult to identify. He was known only as 'Canadian', but it is believed that his name was Mr Coleman. He had stayed at

a lodging house in Hull until the day of the murder but was not seen afterwards. He was known to roam from town to town and was a beggar. According to the information the Police had, this man has served two years' imprisonment in Canada and had been 'inside' for a short sentence in Winchester Prison in 1926. But the information they had to hand neither identified him in the Criminal Record Office or at Winchester Prison.

One person who was thought to be 'Mr Coleman' was a James Orsbourne. He had lived in Canada for about six years but had returned to the UK. His brother was a skipper on a trawler out of Grimsby and it was thought Mr Orsbourne had 'stowed away' and so was technically missing at the time of the murder. He was interviewed by the detectives but it was thought he probably was not the man they were looking for. Even though the description of 'Mr Coleman' was quite similar to that of the 'saw bench man', the Police had nothing material against him.

On 21 March 1936, a reward of £100 was offered for information leading to the arrest and conviction of the murderer. Reward bills were dispatched throughout the British Isles and prominently displayed in Hull and the surrounding area. Details were also widely published in the Press, both national and local. This reward was increased to £250 a few days later but still it did not have the desired effect.

On 27 March, DCI Sands and DS Griffin returned to London to confer with other senior officers and during the weekend a thorough review was made of the statements which had been taken during the enquiries.

On 30 March they returned to Hull, where they remained until 9 April 1936. During that time they continued to interview likely suspects and check up on their movements. Further enquiries were made and the whole ground gone over again in Hull, the docks and surrounding villages. A number of informants had been seen but no information of any real value was obtained.

A possible line of enquiry was opened up when they were contacted in early April by the Glamorganshire Police at Barry Dock. A Norman Edwards, alias Debnam, who was a known criminal and was currently serving a six-week sentence at Cardiff Prison had been in possession of a wallet when arrested and had refused to give any information as to his movements or whereabouts for the 13 March 1936. This man had definite connections with Hull and had been convicted there on four separate occasions. He was interviewed by DCI Sands and DS Griffin at Cardiff Prison on 15 April. Unfortunately the 'wallet' only proved to be a small folding notecase. After they had inspected this and his clothing and found no evidence to link him with the murder and, though there was no corroboration as to his movements at the time of Mr Walker's murder, they were satisfied he had no connection with the crime.

Another known criminal but also a man clearly suffering from psychiatric condition or what was then referred to as being 'mentally defective', made a confession to the Police of the murder of Mr Walker. However, the Police thoroughly assessed the confession before concluding that it did not help the inquiry.

It was made by a twenty-nine-year-old-man, Mr James Burson, alias Benson, who by then had six convictions for larceny and fraud and had been convicted at Worcester Quarterly Sessions in October 1933, when he had obtained money by false pretences. He had been arrested in Manchester on 14 April 1936 and was handed over to the Staffordshire Police at Tettenhall. He was on a charge of obtaining a pony by false pretences, but there were also other charges pending against him. At the time of the investigation into Mr Walker's murder, he was awaiting trial. A doctor's report had also been prepared.

Mr Burson had made a statement and signed it at Tettenhall Police Station on 14 April in which he all but confessed to the murder of Mr Walker in Hull. However, subsequent enquiries were made both in Manchester and Doncaster where he had definitely been, which did not corroborate his story. If anything it suggested the contrary. But he was interviewed by DCI Sands and DS Griffin on 21 April in Birmingham Prison. After being cautioned he made a long statement, which seemed to come in two distinct phases. In the first part of the statement he appeared capable of some rationality, but it became increasingly apparent to the detectives that he was unclear in his descriptions of the premises in George Street and the position of the body, together with the approximate timing of Mr Walker's death.

After Mr Burson had completed the 'first part' of his statement he was asked to sign it; however, it was at this point that he became quite agitated. There were intermittent bursts of him crying, and what he said was disjointed – but it was this that was recorded in writing and formed the second part of the statement.

It is worth discussing Mr Bursen's statement in more detail. In the first part he described how, after the attack on Mr Walker, he disposed of the 'cosh'. He went on to describe the wallet he said he had stolen, and that he had also stolen a mackintosh. He repeated all of this though in the second half of his statement and also explained he had not accurately described the layout of the shop and workshop, nor the time he claimed to have committed the crime.

In the second half of the statement he also described a partner in the crime. This did tend to fit the known facts more accurately, but when he reached a certain point in the statement he clammed up – there was no further information no matter what, nor did he give any useful information to assist the Police in identifying his partner. All that he did say was that he had met him in Birmingham Prison in 1935 when he (the partner) was serving a short term of imprisonment. However, the Prison Governor at Birmingham investigated this quite closely but could not identify who it was Mr Bursen referred to. In the end, DCI Sands was left wondering if the man Mr Bursen described did actually exist.

However, the Police continued to investigate Mr Bursen, they felt he had perhaps either committed the murder with or without an accomplice, had received the true facts through the criminal grapevine or from the person really responsible; or that from newspapers he had 'read between the lines' and was

able to reconstruct the crime in his mind with some accuracy – though he did say he had not read a newspaper for some time.

Mr Bursen also said he had met a man in Manchester Prison in April 1936 with whom he had planned a similar crime to that of Mr Walker's attack. This man had shown him about £20 in cash and also a revolver. He had claimed they were the spoils of an office break-in not far from the main Manchester Police Station. Later enquiries did substantiate that a case of office breaking had occurred at about the time the accomplice allegedly told Mr Bursen it had occurred.

DCI Sands and DS Griffin went to Wolverhampton when Mr Bursen was due before the Tettenham Petty Sessions on 23 April. They also met Supt Mulchinock from Hull City Police and the three of them were present to interview Mr Bursen again. His mental state had clearly deteriorated and it was the consensus among the policemen that no useful information was likely to be obtained. But he did give them a name: Owen. A Mr Harold Owen had been in Birmingham Prison with Mr Bursen in 1935 – but this man was in Liverpool Prison at the time of Mr Walker's murder.

As for the 'cosh' Mr Bursen said he had used to attack Mr Walker, the Police were anxious to follow up what he had said about its disposal. They travelled to Manchester to interview a John Thomas Gee to whom Mr Bursen said he had given the 'cosh'. However, Mr Gee emphatically denied any knowledge of the 'cosh'. And there was also no trace of the mackintosh Mr Bursen said he had stolen, nor of the wallet.

Therefore, not one point in Mr Bursen's 'confession' could be corroborated save for the cash and revolver he said his associate had stolen in Manchester, but then he got the sum of money wrong. It was thought that most if not all of Mr Bursen's statement was fabrication. The information regarding the cash and revolver were passed on to Manchester Police.

The three policemen then returned to Hull where a review of all the facts and statements was again made. Some further correspondence from Mr Bursen claimed that an Owen Wainright had been his accomplice in the murder. Enquiries in this were to be followed up, but it was difficult to trace Mr Wainwright, and again DCI Sands had some doubt as to whether he actually existed.

Well over 1,000 people were interviewed in the inquiry into the murder of Mr Walker. The Police interviewed men in various parts of the north, the north east and west, and south to the Midlands. They also pursued lines of enquiry in London and South Wales.

The adjourned inquest was fixed for 15 May 1936 and the Scotland Yard officers attended. But by now over eight weeks had passed since the murder.

This case is a perfect example of where the Police wanted to solve the crime, rather than just get a conviction. Their approach seems faultless and they treated all suspects and others with courtesy and fairness. They did not just go out and arrest the 'most likely' suspect – a term to be returned to – and build

a case around him. DCI Sands' report in the Archive is a model of its kind and I am indebted to him as I took it as a starting point to my re-telling of the crime.

<center>*</center>

It is well known that the Police are abused and this abuse can take a variety of forms, from the absolute direct violence to the persons – to the more subtle, such as graffiti. But one form of abuse that seems to escape attention is hoaxing. It might be thought that this is not abuse of the Police, it is abuse of the victims the Police are serving; however, the words 'abuse' and 'hoax' would definitely fit in together somewhere.

It may be that the hoaxer is not deliberately trying to adversely affect police activity; it might just be a sign of ill-health. It is true that in the more severe psychosis, thought disorders – delusions and paranoia – are common features but their severity can fluctuate. But this is a world away from the horribly and misleadingly labelled 'attention seeker'. Their behaviour is something they might not be able to easily control, but it can be disruptive, and in the wrong place at the wrong time can wreak havoc. But the 'attention seeker' may not be deliberately out to cause disruption and may simply not stop to consider the consequences. 'Attention seeking' is a term which is now more of a cliché, but it is giving way to another euphemism insofar as 'un-met need' seems to be the term in vogue. The 'attention seeker' has a need for something, and probably if they could describe what it is they are in need of, then that need might be met and their behaviour might then conform to more acceptable boundaries. But getting rid of the term 'attention seeking' and replacing it with 'un-met need' does not address the problem.

Whether these two phenomena are perfectly described is not the most important consideration here. It is their mere existence it is necessary to recognise, and have in mind for a consideration of the hoaxes in the case of Mr Walker's murder. The following are only examples, of which there are many more, and they come under three roughly defined categories: direct hoax by letter, disinformation and false confessions.

DCI Sands received, directly or through Scotland Yard, a number of letters probably from different individuals which told him quite clearly who the culprit was. They came from a variety of places, for example, Plumstead, Colwyn Bay, Walworth and one from a mental hospital in Staffordshire. The problem was that a great deal of time needed to be spent on investigating the claims in the letters. And unfortunately the information in the letters did not move the investigation on. As an example, two of the letters can be discussed more fully and are short enough to be quoted in full (presented as they were written).

HULL CITY POLICE.

Criminal Investigation Dept,
Alfred Gelder Street,
21st March, 1936.

MURDER.
£100 REWARD

In the early hours of the 14th March 1936, the body of Oswald Fisher Walker was found in his workshop at the rear of the shop 29-31 George Street in this City, death having been caused by blows from blunt instrument(s) inflicted by some person or persons unknown.

The deceased was last seen alive in his shop about 7-15 p.m. 13th March, 1936.

The murderer(s) apparently left the premises by a door which leads into New Garden Street. This door was found to be locked, but the key which had been left on the inside of the lock was missing.

This key is described as:— heavy and rusty, and of the box lock type.

Robbery was undoubtedly the motive, as a number of Bank of England £1 or 10/- notes, miscellaneous correspondence, a driving licence in the name of Oswald Fisher Walker, also two photographs (postcard size)—one of the deceased, and his wife, and another—of a family group, are missing. These are believed to have been contained in a brown leather pocket wallet.

The above reward is offered to any person who will give information leading to the arrest and conviction of the murderer.

THOMAS E. HOWDEN,
Chief Constable.

R. RICHARDSON (HULL) LTD., Commercial Printers, 31 Scale Lane, Hull.

The 'wanted' poster put out in an attempt to gain information on Mr Walker's killers.

Sir,

Regarding your appeal for the man with the scowl as the wanted man for Mr O. F. Walker's murder, there is a man living at a shop at the corner of Emily Street and Pelham Street who answers to the description of the wanted man. Since the murder he has changed some of his clothes ie trousers which were dark are now flannels, and his cap is also new now. He has also just removed from one shop, and he is a kind of junk dealer etc, and also has been to prison for burglary. Sorry I cannot disclose his name as I do not know it.

And:

Dear Mr Sands

With no malice or bad intent to any one i say this Remember that Please, hopeing you will think i am not daft and hindering you trying to help you just been reading Daily Express And this has come back to me it may help (Now listen i am sure sure Don't forget Re picture in paper of the Gentleman some days before this happened I am not sure yet of Date he did go Down a street in Osborne St a Public house at top they was trotting some horses up and Down the street I am not sure of the Street just now if it is upper Union or lower Union street At the far end of the Street seems he went in Archway this may help you Now once again i am sure that was the gentleman.

Both of these claims were investigated by an experienced officer.

It must be mentioned that these are transcripts of handwritten letters so the use of capitals inappropriately may be habit. They are both striking as the spelling is almost perfect which rules out any deficiency in literacy, and illiterate people have merely missed out on education, it is not necessarily a sign of a poor intelligence. The first writer seems bogged down in trivia and one wonders that if the described man was a burglar, then did they have a grudge against him, if so, why. The second writer makes a spelling mistake but only one, but with the complete absence of punctuation it suggests a disguised style rather than an illiterate style. The second writer also talks of a 'Gentleman' and a 'Public House' and not, for example, a 'chap' and a 'pub'. The first letter flows with grammar before its content deteriorates into trivia, but the second could well be a perfectly written letter which was then cut up into several dozen slips of paper with phrases on, and then roughly tacked together.

Although both letters were declared to be hoaxes, it is interesting that the first letter does seem to give some information and support some of the assertions with 'facts', so the writer may have had genuine intent. The second, however, gives little information. It is possible that writers of anonymous letters go to such measures to cloud their identity that they actually cloud what it was they are trying to say.

As for the idea of disinformation, the disinformation DCI Sands received from another source came by letter too, but the letter(s) were actually sent to

Mr Walker's widow at her home. This caused understandable distress and upset and, as well as being information as to the culprit, also included veiled and direct threats. And the writer could have been prosecuted, but DS Griffin noted that Mrs Walker was not quite fit and able enough to support a prosecution. The letters were sent by a Mr Biggs: he used several aliases as well as a variety of supposed Christian names so it is to avoid confusion that he is referred to as just 'Mr' here. He was a serving soldier with the Northamptonshire Regiment stationed in Punjab in India. Just how he came by the information he claimed to have is not at all clear, but he does say it was a part of conversations he had whilst in prison. As an aside, he was in prison for 'wilful damage': throwing stones at motor cars!

The first letter was dated/postmarked 19 April 1936.

Dear Mrs.

Just a few lines to tell you how sorry to hear about your husband because I know that he was a free hearted fellow, and would not see anybody down and out.

I know the chap who done that terrible thing I read in the paper and I am willing to tell you where he is and what he looks like for the sum of £60 for telling you, and do not let the Police know about it. Well I hope you will agreed with my confession.

Your
Truly
Friend
M. P. Biggs

But Mrs Walker did not bite; she simply passed the letter onto the Police. The tone in the follow-up letter speaks for itself. This letter is edited and excludes unnecessary details of Police and regimental activity towards Mr Biggs.

Mrs. Walker,

Just a few lines to tell you that you are a dirty lie and you shall pay for it like your husband was. I know why he was killed and it will happen to you.

And why did you tell the police about the letter I sent you

There were a visitor here asking me about your husband affair and I told him a load of lies and if I will give you the letter which I received from the chap who done your husband in.

For 200 pounds and not a penny less, and dont let the police know about it.

Or if you do you wont live very long. you will go the same way as your husband did

Yours truly,
J. M. B.

A really nasty letter, but it is unclear as to what happened to Mr Biggs in the overall picture.

The false confessions amounted to several, but one particular confession was, as discussed, made by Mr James Bursen. Here was another nomadic occupant of the twilight world between fact and fantasy. He used a number of names and aliases some of which were close to reality and others which were not. When DCI Sands and DS Griffin met him he said:

'It is no good beating about the bush, I did it.'

But he didn't and this was soon established, as discussed in the text. Inspector Harry Challoner knew him well and it might be best to let him speak:

'... He is a confirmed and convincing liar.'

*

Murder is considered as the 'ultimate' crime and it is difficult to think of anything worse than taking another's life. Victims of other crimes may decry the Police for not catching the burglar or not putting the resources in to catch a vandal. But in murder the whole objective is to catch the culprit – in many cases it will be an extreme 'domestic' which is a double tragedy for any family, but in Mr Walker's case it seems the murder was committed in the furtherance of another crime – that of theft, though there were, and remain, doubts to this. But if the killer has the motive of simply getting away with his loot, then by killing he is snuffing out the one light that may have helped catch him. The idea of a thief using extremes in violence to escape capture is echoed in other stories in this book. But without any clear leads the work of the Police is uphill from the start; the range of suspects is often a daunting range, and here the reliance on help from the public is often the only way forward. But the reliance of memory to describe an individual, even one seen in strange and unlikely circumstances is not always reliable. And this is not a criticism.

The Police operate in a number of ways but the two most obvious are the catching of criminals after an offence has been committed, but also to prevent crimes happening in the first place. Unfortunately it is a fact that the success of the Police is measured in the number of convictions they can get, but this is not new, and it is not accurate either. History has proved that wrongful convictions can and do happen, and this throws the idea of preventative work out of the window. Quite simply if a crime is committed and a correct conviction is obtained then the possibility of re-offending by that individual is diminished, albeit slightly; though it is true that prisons are efficient schools of crime. But if a wrongful conviction occurs, particularly in a case of murder, then the message to the real culprit is unthinkable.

In the final case of this book I look at a murder where the accused was convicted and hanged, but was almost certainly innocent. It is not a comparison of the case of Mr Walker; such comparisons are beyond the plan of this book. But it is worth considering for a moment that a jury must be satisfied 'beyond

reasonable doubt' of the offender's guilt before they can convict. These days it is not unusual for the question of 'what is reasonable' to be identified, if not addressed. But when one thinks about it, it does allow each sitting of each Court to examine each case individually; there are draw-backs to the jury system, but this often depends on how Counsel and the Judiciary prepare them for their job.

There was not a jury for the murderer of Mr Walker, but a thorough investigation that left every stone upturned. And DCI Sands is more than entitled to the last word:

'Unfortunately, we are far from solving this particularly brutal shop murder, but this is not due to lack of effort by all concerned. Everyone has worked whole-heartedly with a common object and on looking back I cannot recall a single avenue that has not been fully explored.'

The murderer of Mr Oswald Walker was never identified.

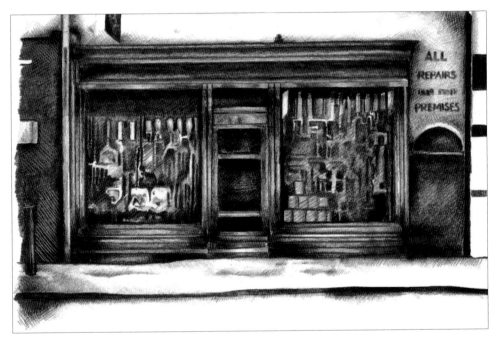

Artist's impression of Mr Walker's shop around the time of his murder.

MARGARET DOBSON, WOLVISTON, 1938

It was Mr Pickering who built the last three houses in Pickering Street, the rest had been built about nine or ten years before together with the pub over the road – The Ship Inn on the corner. At No. 4 were Mr and Mrs Albert Teale and their three children. It was late on a cold Tuesday afternoon in January that Mrs Teale looked out of her back bedroom window and saw her neighbour return to the back door of his house from the coal shed at the bottom of the garden. Mrs Teale had her young daughter Dorothy with her as a train high on the bank went through Haverton Hill station on its way to Port Clarence. Her neighbour, Robert, had been visiting friends in nearby Wolviston that afternoon and left them at about 4.40 p.m. He cycled home to Haverton Hill from Wolviston, which took him about twenty minutes, so he had wasted no time at all in starting a fire; or in helping his father start the fire. Earlier still in the afternoon, Robert cycled to Wolviston and was seen to go to his friends at about 3.25 p.m. Prior to that, from about 3.10 p.m., he was on the road from Newton Bewley with another friend, and he had been having a drink in the Blue Bells Inn since just about 1.15 p.m. – the Landlord and his wife knew him well. So from just after lunch until after five that afternoon he was either with someone or someone had seen him.

That afternoon a sixty-eight-year-old lady was raped and murdered at the time Robert was in others' company, on the road with company, or helping his father make up the fire as observed by Mrs Teale. Only for twenty minutes was he alone, but the fact that he departed one place and twenty minutes later was seen in another should give him no time at all for detours or other activities. Nevertheless he was tried for the murder, found guilty and hanged in May 1938.

His father, Frederick Hoolhouse, was a Suffolk man by birth and breeding but had fallen in love with Miss Florence Martin, whom he married in Richmond in Yorkshire in 1914. They settled in the north-east – Florence was originally from Melsonbury in Yorkshire. They had three children: Gladys in 1915, Robert in 1917 and Clara was born late in 1918.

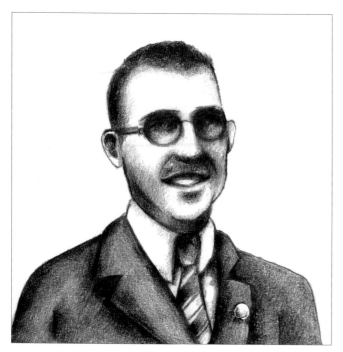

Was Robert as much a victim as the other murder victims in the book?

The former residential side of Pickering Street where Robert Hoolhouse lived and was seen far too soon after the murder of Mrs Dobson. The seven houses were packed tightly together and this does not come out in the picture. If Robert's neighbour looked out of the window as the train pulled into the station, there would have been light enough to pick him out. The bank at the back of the picture, where the trees are was the station. It is uncertain when the houses were demolished.

Unfortunately Clara died before her second birthday. Robert was the apple of his Mum's eye and '... his nature was rather mild and pleasant.' He was a quiet individual; he left school at fourteen and was said to be a scholar of a cheerful disposition. He drifted though from one farm labour job to another, but by the time he was twenty had made application to be a postman – he had worked for the Post Office temporarily at Christmas time. Presently he was still engaged in farm work, which didn't greatly enthuse him. His father had been a farm worker and they had worked together, though lately Mr Hoolhouse senior described himself as a labourer. Robert had a group of friends as well as casual acquaintances but was particularly friendly with a chap Edward (Ted) Lax and also his sister Dorothy; however, Dorothy and he were not in fact romantically linked, and he didn't have a steady girlfriend.

Henry Dobson owned High Grange Farm and his father had owned it before him; it is quite likely Henry was born there. Mr Dobson had had three elder sisters and an elder brother (his brother, Ralph, died young), but at about the time of Queen Victoria's death Mr Dobson was building a life of farming on his late father's farm with his own young family. He was married to Margaret and they had two children. Margaret's life was to end in tragedy in January 1938 when she was murdered on the farm track that joins High Grange Farm to the main Billingham to Wolviston road.

In the immediate pre-war period, County Durham still boasted many farms despite being a focus of the Industrial Revolution with large towns such as Middlesbrough to the south, Hartlepool to the east and Sunderland to the north springing up at a rapid rate. The birth and growth of the railways had fuelled the growth too as mine owners wanted to get coal to ports quickly for distribution by ship around the country. But farming remained a staple industry despite the industrial conurbations that grew up around it.

Many farmers had tied cottages for their farm workers, who were known locally as 'hinds', and at one time in the early 1930s Mr Hoolhouse worked as a 'hind' for Henry Dobson; Robert had also been employed there at the same time. But this relationship went sour and the Hoolhouse family left the farm. It seems Mr Dobson became angry and Mr Hoolhouse reacted. Records are sketchy but there was said to have been quite remarkable agitation in both the Dobson and Hoolhouse camps, and the Police were reported to have become involved.

Even though it had been five years before, the event was considered a material fact when Robert was arrested for the murder of Mrs Dobson. He also had blood on his clothes; he gave a false account of his movements of 18 January; and he had a knife which could have been the murder weapon. He was also said to be in the locality at the right time. But a man seen where the body of Mrs Dobson was ultimately found had been wearing clothes Robert did not possess and the estimated age of the man was way above Robert's. There was also a bicycle across the farm track which was thought to have been Robert's. None of this should have led to his conviction, but convicted he was, and hanged.

The farm track where Mrs Dobson was murdered – below is the same view taken today. There is very little change – a new tree and taller bushes to the left.

Portrait Mrs Dobson.

There was no forensic evidence to link him with the crime, and vital evidential opportunities were ignored or missed. No testimony was offered in his defence, his Counsel, Mr Arthur Morley KC relied on the fact that the case was not a safe one to leave to the jury, but the judge disagreed. On five separate occasions in his summing up, the judge referred to Robert's evidence as *not true* when it may simply have been mistaken. Counsel for the prosecution made much of Robert's alleged activities that afternoon in that he made a statement to the Police which was not accurate as to times: but in the case generally, only one witness out of the many could give an accurate timing of events (if he was telling the truth).

However, another witness could give a pretty accurate approximation of time if her evidence had been presented, but it was suppressed. The prosecution also made much of the blood that was found on Robert's clothing (he had not attempted to wash it), and his handkerchief (which he could have thrown away), and that he had a pen-knife which could have been the murder weapon. This was never proved and the majority of the blood was not sufficiently abundant for grouping; moreover no expert could tell how long the blood had been on his clothes. There was also evidence, as they say, conspicuous by its absence – congealed semen was not apparent on Robert's clothing. One witness completely disappeared – he witnessed an event, made a statement, his presence was noted by a couple of other witnesses and the Police; then he disappeared from the documentation – instead of three men making a delivery of livestock to the farm, it was suddenly two.

These issues together with some others make this case well worth reconsideration. But it does leave one with the chilling thought that if they (we) hanged the wrong person then they (we) may have allowed the real killer to get away with this crime. Of course, the contribution of science to crime detection has developed greatly over the years, but a clear and definite use of guess-work by one of the scientific specialists can be identified, and it can further be demonstrated that the guess was questionable. All too often the Police are criticised for the way they handle an investigation, but here there seems a general sense that they firmly believed Robert was the culprit.

Although some of the documents may have gone adrift over the years, the trial transcript (apart from Counsel's closing speeches) is intact as are many of the other documents: statements used and not used, scientific reports and so on. Legislation has also changed insofar as the Police are much more stringently controlled about what they can and cannot do. What is also present in the Archives are documents that give a good insight into the rather unfortunate attitude of senior civil servants 'supporting' the Home Secretary at the time – though 'supporting' may not be an adequate description. It was a case where many thousands of signatures were collected in support of clemency after the sentence of death and the majority of Durham MPs of the time wrote to their colleague the Home Secretary (Sir Sidney Hoare) personally.

One argument in support of the Jury System runs along the lines that they see the witnesses (including the accused) and so are in a more favourable position to consider the evidence. This assumes that, as discussed above, guess-work is avoided and facts (all of them!) are given for their consideration. When this study is completed, the question can be considered – if the jury heard all of this, then what would their decision have been?

*

John Sedgewick pushed his tool-laden bicycle up to the farmhouse at High Grange Farm and knocked on the back door. Margaret Dobson answered and he enquired as to the whereabouts of Henry Dobson for whom he had been working. He was a hay cutter and at just after 3.00 p.m. had finished for the day, though he was to double check the stacks he had made to make sure they were well covered. Mrs Dobson told him that her husband was in the yard but, as he turned away from the door, he could see Mr Dobson approach the farmhouse. The two men discussed the weights of bails and soon John Sedgewick left the farm. Mr Dobson went in for his tea.

That morning, Mr Dobson had gone to Sedgefield market to sell some livestock but he also purchased some young livestock to rear on the farm. The beasts were due to be delivered later that afternoon. It is unclear precisely what his usual routine was, but he had gone into the farmhouse for his tea somewhere around 3.10 p.m. He had what he described as just 'plain tea' but Mrs Dobson had a boiled beef sandwich. Mrs Dobson was also busy writing a

letter to her sister-in-law who lived in South London. It had been her plan to go into the village of Wolviston after tea to post the letter, to place an order at the grocer's, and put some shoes in for repair. Tea was finished, that is to say she had finished her sandwich and Mr Dobson had finished his tea by about 3.30 p.m. He returned to his farming duties.

There were various people in the farmyard when Mr Dobson went out after tea. Francis Brannigan was milking from about 3.30 till 5.00 p.m. Thomas Adams was in the yard preparing for a threshing session to be held the next day – he said he was there from about 3.15 till 5.00 p.m. Charles Adams was in the yard cleaning a cart until about 4.30 p.m., then fetched some coal for the threshing machine. And from about 2.30 until about 4.30 p.m., three men, Bertram Smith, William Coates and Robert Ervin, who had brought the threshing machine to the farm, were preparing it for work the following morning.

Buried in the trial transcript is a small insight into Mr Dobson's power of hearing. Mr Justice Wrottesley commented that Mr Dobson was '... hard of hearing' which Counsel for the defence agreed with. This is significant because at about 4.30 p.m. Mrs Dobson had come into the yard – Mr Dobson said he was at the '... bottom of the yard.' (From the back of the farmhouse to the furthest point in the yard before the buildings is a good forty yards.) And Mrs Dobson shouted that she was going into Wolviston and may go on to see Mr Dobson's cousin later. As Mr Dobson was '... hard of hearing' it would be necessary for Mrs Dobson to raise her voice when talking over that sort of distance, but all of the men in the yard said they did not see Mrs Dobson that afternoon. And it does seem likely that the majority of the men were actually in the yard at the time – only Francis Brannigan was milking, which would probably place him in a building and possibly using machinery which might create some diversionary noise.

As Mrs Dobson had to attend shops to place an order for groceries and deposit shoes in the shoe menders, it would mean her departure would have to be sooner after tea, rather than later. The farm track down to the main Billingham to Wolviston road was to be her route of choice (another track goes off due north to the Wolviston to Newton Bewley and Hartlepool road). But also using this track were the three men who had brought the threshing machine to the farm – they were said to go down the farm track at about 4.30 p.m. when a 'buzzer' sounded. (No details of this buzzer are available but it might have been the nearby ICI factory.) Only one of the men said he heard this buzzer. The men did not see Mrs Dobson or anyone else or anything out of the ordinary on the track – so it is probable that Mrs Dobson did not go down the track herself until after them. In evidence, Mr Dobson said his wife departed before the men and he had seen her go down the track himself, but he was adamant that she did not carry a shopping bag. Therefore, it is probable Mrs Dobson returned to the farmhouse after 'shouting' to Mr Dobson in the yard, because when her body was later recovered there was a shopping bag with her. The probability is then, that the three men who had brought the threshing machine left and went

down the track before her. As Mrs Dobson was murdered just off the track and was still in possession of the letter she had intended to post as well as the shoes she intended to leave in at the shoe repairers, then it is quite certain she did not get to the village. It is therefore more likely that she left after the three men and was murdered on her way to the village. As the attack would have taken a few minutes, and the rape similar, and it would take her about six minutes to die from her injuries then it is reasonable to assume that the three men passed what was to be the scene of the crime, but before Mrs Dobson got there. They also said they did not meet anyone coming up the track.

After the event, PC John Chapman attempted to approximate how long Mrs Dobson would have taken to reach the scene of the crime from the farmhouse. He thought she could cover the 480 yards in about nine minutes, which would place her arrival there at about 4.45 p.m. The thresher men left at 4.30 and Mrs Dobson was soon on their tails, say at 4.35 p.m.; nine minutes to get to the scene which therefore takes the time to about 4.45 p.m. Although Robert left his friends at about 4.40 p.m. and it would only take about a minute or so to cycle to the scene of the crime from where his friends lived, there was no mention that the three men of the thresher party (who knew him well as he was often working with them) who said they went into Wolviston village after they reached the end of the farm track, actually saw him. Clearly these timings are approximations but it does give some idea of how tight the opportunity was for him to have committed the crime. But this is only the start of the doubt surrounding him.

Assessing the time of death when it comes to a breakdown of minutes is difficult. As Mrs Dobson's body was not found until the following day, and so she had lain in an open field through a January night, then body temperature would not have been of any use. At a post-mortem examination a good approximation can be made depending on stomach contents if the timing of the last meal is known. But this is not definitive. As a general rule, food will start to leave the stomach and pass into the small intestine about half an hour after it is eaten, but an upper limit can be as much as two and a half to three hours. As far as could be ascertained there was no reason why Mrs Dobson's digestion should fall out of this approximation. However, it is known she was nervous of walking this track after dark, but it was only dusk. It is widely accepted that in cases of fear or terror the digestive system may stop functioning temporarily as the nervous system channels all energy into 'fight or flight' – but Mrs Dobson's fears fell short of what could be considered as extreme fear or terror. Mrs Dobson had made this journey before at this time of day; she had lived at the farm for about forty years.

But with other events it is possible to say that if Mrs Dobson left the farmhouse within a few minutes of 4.30 p.m. and the lorry delivering the new livestock Mr Dobson bought that morning was to arrive between about 5.10 and 5.30 p.m., then she probably died somewhere between 4.45 and about 5.30 p.m. This too can be fine-tuned a bit – if Mrs Dobson left, say, within five

minutes of 'shouting' at Mr Dobson and the departure of the three men who were also travelling the track, pushing their bicycles, then she would have arrived at the scene of the crime about nine minutes or so later, or say about 4.45 p.m. But she would not have travelled any further and it is doubtful that any delay would occur – attack, subduction, rape and kill takes a short time. It is not clear when the first stab wound was made in consideration of the other events of the crime but it can be approximated that after the stabbing it would have been about six minutes until she died. This is going to take the time up to about 4.55 p.m. And this would be consistent with what the Pathologist found at post-mortem.

But this is only an approximation, the lorry arrived with the livestock at somewhere between 5.10 and 5.30pm (there were three men on the lorry and two of them said 5.30 p.m. and one said 5.10 p.m. – a point to be returned to). It is probable Mrs Dobson was dead by the time they arrived. And a man was seen at the scene, said to be acting strangely: from standing just off the road, he dived down onto the ploughed field when caught in the livestock lorry's lights. It was held later that this was Robert Hoolhouse, but as discussed already he was a twenty-minute cycle ride away and at home where he was seen at just about 5.00 p.m.

<p style="text-align:center">*</p>

It might be helpful to show Robert's movements in more detail after he left home at about lunchtime on 18 January, until he got back home.

And this is as good a place as any to say that the one problem with witness evidence is the overwhelming problem human beings have – they are fallible. Two examples to demonstrate this: firstly at what time people saw him, and secondly, the variety of head-gear he was seen in on the very same afternoon – but, just for the record, Robert said he wore a cap.

Unfortunately, one of the most fallible witnesses was Robert himself. When he came into the Police Station, to 'help the Police with their enquiries' it was approximately 1.30 a.m. on Thursday 20 January. He was interviewed by Detective Sergeant Edward Foster who wished to know his activities and whereabouts for the Tuesday afternoon – 18 January. Robert explained his visit to his friends, but he gave the Police the approximate timings he had made on the *Wednesday* when he visited, rather than the Tuesday. However, despite the late hour, the Police went and knocked the people up to check his story.

Dorothy Lax was the younger sister of Ted and very friendly with Robert, and it was her he had visited on the afternoon of 18 January. Also present was her aunt, Beatrice Husband. Dorothy confirmed Robert's attendance on the Tuesday afternoon but instead of his timings, in that he left at about 3.30 p.m., said he left at about 4.40 p.m. Miss Husband said Robert arrived at about 3.45 p.m. and stayed about an hour. When the Police went back to Robert he said he had made a mistake, and corrected the timings, but no mention was

made to the Police that he may have confused one day with another. Both Dorothy and Beatrice describe him as wearing a cap.

Taking things now in order that the other witnesses had seen him, Robert said he left home at about 12.30 p.m. At 1.10 p.m. he arrived at a pub called the Blue Bells Inn at Newton Bewley. The Landlord was one Charles Smith, who confirmed Robert had been to his Inn, had arrived at about 1.10 p.m., and stayed until about 2.20 p.m. Mr Smith could remember who else was in the bar, Walter Nelson. Mr Smith said Robert wore a trilby.

Mrs Mary Jane Smith was the Landlady and she went into the bar area, she said, at about 2.15 p.m. She remembered seeing Robert, and she remembered he wore a trilby.

The other drinker in the bar that lunchtime was an unemployed labourer, Walter Nelson. He arrived at the Blue Bells Inn at about 1.15 p.m. and said Robert was in the bar (wearing a trilby). However, Mr Nelson stated later that '... when I saw Robert Hoolhouse in the bar of the Blue Bells Inn between 1.45 p.m. and 2.45 p.m. on Tuesday the 18th January ...' Why he changed the timing of his arrival by half an hour is not clear.

By 3.10 p.m., according to another witness, Ronald Baldry, Robert had progressed about a 100 yards from the pub towards Wolviston. In Court, Mr Baldry actually said he wore a wristwatch that afternoon. Robert and Mr Baldry rode together from Newton Bewley to Wolviston (Mr Baldry said Robert wore a dirty or dark brown trilby). Mr Baldry was a patrolman for the AA and when he arrived at a particular point he had to note the time; at Wolviston, he noted it was 3.25 p.m. Mr Baldry's power of recall was tested in Court and bearing in mind that in his statement he had said Robert wore a dirty or dark brown trilby, his memory seemed to have wavered. Mr Paley Scott for the prosecution asked:

Question. 'Do you know what he was wearing on his head?'

Answer. 'I do not, sir. I thought it was a trilby.' So he was not sure about his head-gear, but he had marked the time of his arrival at Wolviston on his time sheet and he had checked the time as 3.25 p.m., but in Court this became 3.35 p.m. One wonders why he said he 'thought' Robert wore a trilby, when before he could even describe detail.

On the road with Mr Baldry, Robert was alleged to have said he was going to see his young lady and if her '... mother is out I hope to get a bit of "dick"'. The assumption was Robert referred to Dorothy who he eventually visited. But Dorothy didn't live with her mother, and later she vehemently denied Robert had made any improper suggestions, or that his conduct was in any way lacking in decorum.

However, before Robert arrived at Wolviston a couple of other witnesses who were reliable insofar as they knew him, made statements to say they had seen him. John Jennings said he saw Robert with Mr Baldry with Mr Nelson not far behind. Mr Jennings was not sure if Robert wore a cap or a trilby. However, his wife, Alma, saw Robert wearing a cap and riding with Mr Nelson. Strangely,

Mr Nelson had said he did not see Robert after he left the Blue Bells Inn.

Ted Lax saw the cyclists, or at any rate, he said Mr Nelson and Robert were riding abreast. Robert, according to Ted, was wearing a light-coloured cap.

Robert got to Wolviston and was timed to arrive by Mr Baldry at 3.25 p.m., later 3.35 p.m. They parted and he went to visit Dorothy.

This is also not without some confusion. Originally Dorothy said Robert arrived at 3.45 p.m., but she was in the washhouse so didn't see him for a while. However, she later said: 'On Tuesday January 18th, 1938 when Robert Hoolhouse was in our house from 3.20 p.m. till about 4.40 p.m. ...' At least she was consistent about his head-gear; he wore a cap.

Mr Paley Scott in examination-in-chief for the prosecution asked her:

Question. 'About what time did he come to the house?'

Answer. 'Well, I saw him about twenty minutes to four.'

But in cross-examination a clearer picture emerges, Dorothy didn't actually know what time Robert arrived. Mr Morley for the defence:

Question. 'Do you know or not what time the accused arrived at your house on Tuesday afternoon?'

Answer. 'No, I do not know.'

Question. 'Because you said, when you were asked "Well, I saw him about 3.40." Had he arrived some time before you saw him?'

Answer. 'Oh, yes.'

Question. 'He had arrived at your house before you saw him?'

Answer. 'Yes sir.'

Apparently she had been in the wash house. But for all this Dorothy was quite consistent with the time Robert left, 4.40 p.m.

Dorothy lived with her aunt (and uncle – her aunt's brother); Beatrice Husband was also in the house that afternoon. As for Robert's head-gear she said it was a cap. Originally she said he arrived at 3.45 p.m., which changed to 3.20 p.m. and finally in Court in evidence she said '... between twenty-past and half-past three.'

So he was seen by a variety of people at a variety of times, or changing times, in varying head-gear. Of the nine people listed above, four said he wore a cap and four said he wore a trilby; one was a 'don't know'. Two of the people who saw him in a cap later changed the time they saw him and two people who saw him in a trilby also made some alteration to the times. But what this shows is how irrelevant some of the evidence is and so if there are some issues the jury don't eventually hear then it might help them see the wood and not the trees, but this is in conflict with their role. It is for the jury to decide this – what a suspect wears and at what time is a matter of fact. So what this catalogue of timings and attire demonstrate is that the withholding of evidence about when a witness sees a suspect is denying the jury their ability to do their fundamental task – to decide the facts. And if Robert was said to leave Dorothy and Beatrice at 4.40 p.m., then it would be of importance for them to hear that PC Chapman

timed the cycle riding time from their house to Robert's house, which he timed at about twenty minutes, and also that about 5.00 p.m., that is twenty minutes after Robert left Dorothy and Beatrice, he is seen at his own house – in the back garden. The jury heard neither that he would take about twenty minutes to get home nor that he was seen there at about 5.00 p.m. Nor did they hear any details of the train Mrs Teale saw.

On his way home from Dorothy's, Robert said he had a 'spill' on his bicycle in which he sustained a cut on his face and also injured his shoulder. The description of the cut didn't sound as though it was the usual gash of someone hitting a surface such as a road quite abruptly and so the Police and the prosecution made an argument that the scratches on his face were caused by Mrs Dobson as she fought for her life. This is something to be considered later, but briefly: no damage was found on Mrs Dobson's gloves, and no skin or blood were found at post-mortem under her fingernails.

Some further confusion seemed to come about because Robert went back to Wolviston that evening. He took the bus from Haverton Hill to Billingham and then caught the bus from there to Wolviston. He and Dorothy went to the cinema together, which might explain why he didn't go by bicycle on his later trip.

But a word or two about witness evidence. It had been thought for a long time in mid-last century that witness evidence should attract some kind of caution. That is to say the jury should be cautious for this reason or that reason about particular evidence. This did come after Robert's time, but it was considered of importance that 'how long' the witness saw what they witnessed, 'in what conditions' light or dark, rain or shine, far or near, short or longer period; whether they had 'seen the suspect before' and 'how often' – identification or recognition. Any impediment to the witness's view? What did the witness remember particularly? Any discrepancy – like a trilby or cap. But with these folk it was more to do with recognition of Robert and there does not seem to be a problem. It was later on when the men delivering the livestock to the farm that really the questions posed here would be crucial, which will be considered next.

*

There is no doubt as to where Mrs Dobson was found on the morning of the Wednesday, 19 January 1938, and there seems no reason to think anything other than that is where the crime took place. Mrs Dobson got to a point in the farm track and encountered someone who had, it was said, come up the track from the Billingham to Wolviston road rather than travel the track behind her. It also seems fairly certain that the three men who made up the threshing party, Messrs Smith, Coates and Ervin went down the track before her; otherwise they may have stumbled across the murder as it was in progress.

The other group to travel the track that afternoon was for the delivery of the livestock Mr Dobson bought on the morning of 18 January at Sedgefield

market. The lorry was at Sedgefield market to load the beasts at 4.30 p.m.; loading would not have taken too long and the drive from Sedgefield to Wolviston was direct. However, there's rather a large gap in the arrival times estimated by the three men on the lorry. Percy Swales, the driver, and Thomas Nelson both said the lorry arrived at the farm at about 5.30 p.m. but the other man on the lorry said 5.10 p.m. Taking it back in time a little, Mr Swales and Mr Nelson both said the lorry was in Sedgefield market to load the beasts at 4.30 p.m., whereas the other witness said it was '... about 4.00 p.m.' An alternative method of calculations is that Mr Swales and Mr Nelson said they started to load at 4.30 p.m. and left the market at 5.00 p.m.; they went on to say they arrived at the farm at 5.30 p.m. John Burns, on the other hand, commenced the loading at 4.00 p.m. and timed their arrival at High Grange Farm at 5.10 p.m.

The lorry came from Sedgefield to Wolviston and travelled south from Wolviston to the farm – so it turned left into the farm track. As it spun round to the left, its light beams would gradually move round to the left picking up anything visible in its path. Dealing with two of the three men first, the driver, Mr Swales, said that as the beam of the headlights focussed on the farm track he saw a man who was fairly tall, about thirty, wearing a cap, short brown smock, breeches and leggings; possibly a farm worker. He behaved strangely, ducking down as the lorry caught him in its lights: Mr Nelson said the man held his arms aloft and when the beam of light illuminated him, he dived to the ground. But far from being fallible, these two witness saw the same, and their descriptions were almost identical. They also described his 'gruff' voice and commented on his local accent. Mr Swales drove up the farm track until he was level with this man who was down to his right, in the field; the plough. By this time he had got to his feet again. As his bicycle was partly across the farm track, Mr Swales had to mount the grass verge to pass it. He spoke to the man who was now outside of the beam of the light so Mr Swales could only recognise his shape. He asked him what he was doing and received the reply from the man that he had been drinking (the suggestion was that he had been drinking a considerable amount: 'I have had one over the nine'). Mr Swales carried on up to the farm to deliver the pigs, he timed the arrival as 5.30 p.m. and the delivery with unloading etc. would take about ten to fifteen minutes.

As well as seeing the exact same as Mr Swales, Mr Nelson said he heard every word said by Mr Swales and the man in the field, despite him being the other side of the cab with the engine running, and a good six feet above the road which was a few feet above the dip in the ploughed field where the man stood. And he recounted the conversation which is word for word how Mr Swales related it.

But the third man in the cab, sat between Mr Swales and Mr Nelson, said he did not see the man in the field nor did he hear any conversation between him and Mr Swales. This does not in itself suggest anything more than one

witness seeing and hearing one thing, and another witness seeing and hearing something slightly different. However, one would expect to find three roughly or even vaguely corresponding statements, not two almost identical and one completely different.

It is therefore worth considering what Mr Swales and Mr Nelson said in their statements in relation to what they later said in Court. And Mr Dobson, for reasons that should become clear, could be included in this too.

Mr Swales made a statement which said of the journey to High Grange Farm 'Thomas Nelson was with me ... There was also a youth between us.' And later, 'I said to the two men who were with me ...'

Mr Nelson did not mention anyone other than Mr Swales in his statement.

Mr Dobson said in his statement: 'There were three men in the wagon.'

The officer in charge of the murder investigation, Detective Superintendent George Kirkup recorded that, 'Burns accompanied Swales and Nelson'.

So it is accepted by the men in the lorry there were three men, and accepted by the recipient of the beasts at the farm, there were three men, and recorded by the Police that three men were on the lorry.

Counsel for the prosecution, in his opening speech, told the Court there were *two* men.

So, Mr Percy Swales examined by Mr Peaker (prosecution):

Question. 'Who was with you?'

Answer. 'Thomas Nelson.'

And then in Court Mr Nelson gave evidence. The way he was examined denied him any opportunity to say who was in the cab. Mr Paley Scott for the prosecution:

Question. 'Do you remember on Tuesday, the 18th of January, going with Mr Swales in a cattle wagon?'

Answer. 'Yes, sir.'

Question. 'To High Grange Farm?'

Answer. 'Yes, sir.'

John Burns was taken out of the evidence, and that effectively put a stop to any idea the lorry arrived at High Grange Farm at any time earlier than 5.30 p.m. So why did person or persons unknown wish to control the evidence? And it is about control because Mr Dobson in his statement said:

'There were three men in the wagon.'

In Court he is asked by Mr Morley for the defence:

Question. 'Did Swales have anyone with him?'

Answer. 'Yes, there was another man with him.'

So Mr Swales seems have forgotten; Mr Nelson was not allowed to remember; and Mr Dobson seems to have changed his mind about John Burns. For a witness to change their evidence is, of course, quite possible. For two witnesses to change their evidence on a similar issue seems a little strange. But for three witnesses to change their evidence on exactly the same point, moreover in his opening speech Counsel for the defence 'predicts' it, sounds as though the jury

were denied the opportunity to consider John Burns' evidence, or that he was ever on the lorry. This makes a mockery of a 'fair trial'.

It should not be necessary to quote Mr Burns' statement in full, but here are the salient points:

> On Tuesday, the 18th January ... I believe it would be sometime about 4 p.m. that we loaded the last load at Sedgefield Auction Mart. The load ... pigs were for Mr Dobson at Wolviston. We went there first. It would be about 5.10 p.m. When we left the main road and gone about 20 yards into the field leading up to Mr Dobson's farm, the driver, Percy – stopped the cattle wagon and I heard him say "What are you doing down there?" I never saw anyone nor heard anyone to reply to the question, and I did not know who he was speaking to, but I did see a bicycle lying near the hedge ... As we moved off the driver said "That fellow says he has had one too many."

If Mr Burns had given this evidence in Court it would not really show much, but the fact that the evidence was suppressed and the other witnesses did not acknowledge his existence and Counsel for the prosecution said before any evidence was heard that there were two men on the lorry then it prompts the questions: Who wanted Mr Burns to be removed from the list of witnesses called? And how did that person know that the three witnesses, Mr Swales, Mr Nelson and Mr Dobson would know to eradicate him?

Francis Brannigan was busy milking that afternoon and in his statement he said:

'I was ... milking until five o'clock. Shortly afterwards I went for my tea but just before Swale's wagon came back with some pigs from Sedgefield.'

The statement is ambiguous because of the way it is punctuated, or not punctuated, but one interpretation is that he finished milking at 5.00 p.m., but *before* he went for his tea Mr Swales *et al.* arrived with the pigs. The significance of this, taken with Mr Burns' evidence, times the arrival of the lorry closer to 5.10 than 5.30 p.m. And it is a 20-minute cycle ride from Robert's house to the scene of the crime – and his neighbour saw him at home at about 5.00 p.m., so he could not possibly have been in the field at 5.10 p.m. Even thinking he was in the field at 5.30 p.m. stretches credibility.

But when one considers that according to both Mr Swales and Mr Nelson, Robert was wearing clothes he did not posses and was aged about thirty instead of twenty it does go to show how weak the evidence was.

In the last chapter, the 'Turnbull Rules' for evidence were introduced. That is 'how long' the witnesses saw what they witnessed, 'in what conditions' light or dark, rain or shine, far or near, short or longer period; whether they had 'seen the suspect before' and 'how often' – identification or recognition – any impediment to the witness's view? Why did the witness remember particularly? Considering they saw the suspect, as a lorry with headlights on highlighted him for a couple of seconds at most, then they have been super-humanly observant.

And they both could list his clothing identically, which is incredible. Unless they were helped. And both Mr Swales and Mr Nelson made identical mistakes about his age and what he wore, unless the man they saw was not Robert.

But there was the bicycle. Robert had a bicycle and Mr Burns saw a bicycle! Is it satisfactory that the bicycle, if it was Robert's, was sufficient evidence to send him to the gallows? But if either Mr Swales or Mr Nelson or Mr Burns could identify Robert's bicycle ...

*

Mrs Dobson had often gone into the village late in the afternoon and would sometimes go on to visit friends or relatives; she had told her part-time helper, Clara, she intended to visit the wife of Mr Dobson's cousin on the evening of Tuesday 18 January. Mrs Dobson was great friends with this lady, Mrs Thompson. She lived in West Hartlepool and this had been a fairly regular trip for Mrs Dobson and she would be expected back at the farm at about 8.30 p.m.

Mr Dobson finished his duties on the farm and went in for a wash. He said he sat over the fire to read the newspaper from about 6.30 p.m. However, as the usual time for his wife's return, about 8.30 p.m. passed, Mr Dobson began to feel uneasy. He took a lamp and went down to the main road where he met the next bus from West Hartlepool. But his wife was not on it. He waited then for the next bus to discover she was not on that bus either. Mr Dobson wondered, as his wife was going to the Post Office that afternoon, if there was the possibility that a message had arrived from their daughter in Newcastle and Mrs Dobson had gone there – High Grange Farm did not have a telephone. In those days urgent messages usually came by telegram, and although this is not mentioned as such by Mr Dobson, it must have crossed his mind. He met the last bus at about 11.35 p.m. before he returned to the farm.

He sat up all night in the chair. At 5.00 a.m. the next morning he started his day's work, this was a little relief as it seemed to take his mind off things. But at about 10.00 a.m. there was a bit of a lull in activities and he became quite anxious about his wife, and he had a horrible feeling that something was wrong.

As he had thought his wife had gone to their daughters in Newcastle, Mr Dobson thought he should make contact there first so set off for Wolviston village. He walked up the track and decided to take a shortcut over a field to the north of the track. As he passed through this field he could see further up the track and slightly off to the south of the track a black bundle. He was too far away to make any sense of it but as it was out of the ordinary, he thought he should take a closer look. So he re-traced his steps back to the track and tried to discover where the bundle was. On the track, Mr Dobson could not see anything, but walking very close to the south side of the track, close to the ploughed field, he saw his wife's body. He noted that her face was discoloured and her clothes

were in disarray; her bag was a little distance from her body. He stepped down for a closer look, but it was clear to him that she was dead.

In all probability, it did not really register as to what he had found; this is a part of his statement:

> I stepped down on to the ploughing and looked at her. I saw that she was dead. I then went to seek a policeman.
>
> I found the policeman and told him what had happened and he came with me and the doctor, and I pointed out where the body of my wife was lying.
>
> I returned to the farm and made arrangements for my relatives to be informed.

PC Chapman was on duty and Mr Dobson found him in the High Street, Wolviston. Dr James Craven was passing in his car, so PC Chapman flagged him down and explained; the three men then went out to the farm track.

When they arrived, Mr Dobson pointed and PC Chapman recognised the body as Mrs Dobson straight away. Dr Craven observed the bruising and that the left eye was 'black'. He could see by merely looking at her that she was dead. Dr Craven then conveyed PC Chapman to Billingham Police Station. He made a report to his Inspector (Inspector Joseph Proud) before returning to the scene of the crime with Sergeant Harry Farthing.

The uniformed police officers ensured the preservation of the crime scene until the CID arrived. Insp. Proud also attended the scene. Det. Supt Kirkup, DS Foster and other CID officers came from their headquarters in Stockton.

The CID officers arrived at about 11.00 a.m. and it was with DS Foster that the main bulk of detection befell. Or at any rate his statements are the most articulate and detailed. They examined the crime scene and noted the details. DS Foster said he found some footprints around the body which were preserved and later plaster casts were taken. He interviewed Mr Dobson and corroborated what he said. The focus of attention early in the investigation was the incident Mr Dobson recollected, that the men delivering the livestock the previous afternoon had casually asked one of his farm 'hinds' about a man they had seen drunk, down the track. But also on the track the previous afternoon were the threshing party, Messrs Smith, Coates and Ervin. DS Foster arranged to have statements taken from all of these men and PC John Oates interviewed the men from the livestock delivery, Mr Swales and Mr Nelson. And someone, though there's no record of who, interviewed the third man on the lorry, John Burns. The statements of Mr Swales and Mr Nelson had quite remarkable similarities.

Statements were also taken from the men who had brought the threshing machine to the farm, Messrs Smith, Coates and Ervin. They explained their activities. They finished work preparing the machine for the following morning, then pushed their bicycles down the track to the Billingham to Wolviston road. They all three went north into Wolviston village where they parted, Mr Smith

went to his home, Mr Ervin went on to Greatham and Mr Coates met and spoke to a man, Mr Thornton, before he went to his home on the Sunderland road. Mr Smith gave a slightly different story about the activities in the village when in Court. Mr Paley in re-examination:

Question. 'Which way did you go from there?'
Answer. 'I stayed in the village.'
Question. 'Did you see in which direction the other two men went?'
Answer. 'They went the West Hartlepool road.'

So Mr Smith said his colleagues did one thing and they said they did something else. This might seem a small, pernickety point, but when asked in examination-in-chief by Mr Paley Scott, Mr Smith said of his departure from High Grange Farm:

Question. 'You left at half past 4?'
Answer. 'Yes.'
Question. 'And from there you would go home, I suppose?'
Answer. 'Yes, sir.'

Mr Smith did not go home, he made the journey to Wolviston, but he lived in the other direction.

Detective Sergeant Ralph Lee had taken the plaster casts of the footprints; he also took a series of photographs of Mrs Dobson and the scene of the crime.

At approximately 3.40 p.m., the body was taken to West Hartlepool Hospital and PS Farthing accompanied.

DS Foster made a number of enquiries which eventually led him to Henry Collins who was a regular member of Mr Smith's threshing machine crew. Mr Collins later attended Stockton Police Station and communicated with DS Foster, which prompted a request from DS Foster that Bertram Smith also be interviewed. This led eventually to the Police requesting Robert Hoolhouse to come to the Police Station. This was because Mr Collins had recorded his grave suspicions of Robert which were compounded by Mr Smith. The reason for this was a chance meeting the three of them had (also present was James Fulcher, another thresher operative) outside a newsagent's shop on the evening of 19 January. This is something to discuss further.

Robert attended the Police Station on the early morning of 20 January and made a statement to DS Foster. The latter wished to know Robert's movements on the afternoon of 18 January. Robert related that he had visited Dorothy and was home at 3.30 p.m. DS Foster said he had to verify this, and Dorothy and Beatrice were roused in the early hours to check his story. They gave different times, which DS Foster later confronted Robert with. Robert then amended his statement, but the earlier times he had given seemed to actually fit his activities of the following afternoon. It had been Det. Supt Kirkup who asked Robert if he wished to correct his statement – he said, 'Yes, I was there at the time you say ...' Det. Supt Kirkup informed him that this statement would also be checked and he would remain until it was checked. Robert accepted this.

Robert was asked by DS Foster, 'Have you any objection to me examining

your clothing?' Robert had no objection. His clothes were taken for examination – what looked like blood was found '... a small smear of red on the right side of the peak (of his cap). On his jacket I found one small red stain near the bottom. On his shirt I found both cuffs stained with red inside and out.' Robert was confronted with this find and asked if he could account for the 'red marks' to which he replied he could not.

DS Foster with two other police officers attended Robert's house at 6 Pickering Street and collected a fawn coat with red stains on. Again Robert said he could not account for the stains.

Robert was noted to have three scratches on his face which he said he had sustained when he fell from his bicycle on the Tuesday afternoon. So the bicycle was also brought in for examination.

Robert and his parents were completely co-operative with the Police.

But at 7.15 a.m. on the morning of Thursday 20 January, Det. Supt Kirkup advised Robert that he was being detained on suspicion of causing the death of Mrs Dobson.

The evidence then was: mistaken statement which was corrected; Robert cooperated fully with the Police when they wished to corroborate the statement; there were red stains, possibly blood on his clothing. There was also a handkerchief with blood on it and the Police found a small pocket knife at his home.

However, the Police thought there was relevance in another issue, that is the past employment of Robert and his father, when they lived in a tied 'hinds' cottage on High Grange Farm. A row broke out between Mr Dobson and Mr Hoolhouse of which the surviving documentation both shows one blaming the other. However, the outcome was Mr Dobson ordering Mr and Mrs Hoolhouse off his farm and out of their accommodation. He said the Hoolhouse family were not to come onto his land again.

It seems the evidence was thin, but the Police had taken his bicycle in for inspection. Also on the evening of Wednesday 19 January, Robert encountered Bertram Smith, the thresher operative, and two of his colleagues. It was as a result of this encounter that the Police first became suspicious, so it is necessary to examine the issue.

*

It becomes clear through Robert's words and actions that he was not content with farm work. He mentioned to his friend, Robert Cook at the 'dole office' on Wednesday 19 January that he was having a couple of days rest and he also told John Longthorne that he did not want farm work. Herbert Collins knew he was waiting to hear about a permanent position with the Post Office.

In Court, Mr Smith said Robert did not know that the thresher party were going to Mr Dobson's farm on 19 January, but Mr Collins, a regular on the threshing circuit, had told him. It seems possible that Robert was avoiding the threshing job, as he knew where Mr Smith *et al.* would be on the afternoon of

the 18 January, but made no attempt to actually track him down and ask about work for the following day.

In fact, there was some suggestion in one of the lower courts that Mr Smith thought Robert tried to avoid him on one occasion. This is when Robert had gone to a newsagents shop in Haverton Hill on the afternoon or early evening of Wednesday 19 January to get a newspaper. Also in the vicinity of the shop with Mr Smith were two of his regular helpers on the thresher: James Fulcher and Herbert Collins.

This was the day after Mrs Dobson was murdered and the three men had gone to the newsagent's to change up some money for Mr Smith to pay his workers. It is surprising this became an issue in Court, but Mr Collins was a retired Police Officer and in his statement he said he had become 'very' suspicious of Robert's activities the previous day (the day of the murder) because he said he had gone to Wolviston on his bicycle in the afternoon of the 18 January but returned to Wolviston in the evening by bus. But this is quite easily explained as Robert was going to the pictures with Dorothy in the evening, so he went by bus as his bicycle was not made for two.

In his summing up, Mr Justice Wrottesley advised the jury that a lot of what was said during this encounter at the newsagent's did not move the case on. He felt they should be careful with this evidence as it amounted really to the three men judging Robert's demeanour which could lead to all sorts of confused interpretations.

But considering the conversation as a whole and bearing in mind that Robert was not too keen any longer on farm work, it does allow one to pick out a few comments made and consider them. One thing to remember is that Robert did rely on getting this casual work so it is important that he didn't bite the hand that fed him – that is to say he would make weak but plausible excuses for not joining in with the threshing work, rather than make the blunt declaration that he no longer wished to do it.

As Robert had not worked on the threshing machine for a few days, he could attend the 'dole office' on the Wednesday morning to 'sign on'. He walked up and signed before returning home. He went out after dinner apparently once again to meet Dorothy at her aunt's house. There's evidence to prove this, and there were also a couple of people he met. Also Robert told the Police that he had fallen off his bicycle on the way home from Dorothy's on the Tuesday afternoon.

These two points are relevant because at the newsagent's shop on the Wednesday evening – 19 January – a scenario as to Robert's activities seems to have appeared from nowhere. James Fulcher made a statement to the Police as to what he had heard Robert saying and what was said to Robert by Mr Smith and Mr Collins. He said Robert explained he had his 'spill' from his bicycle on the morning of the 19 January, 'I was going to work this morning and fell off my bicycle.' This seems strange as that morning Robert signed on at 'the dole office'; he didn't go to work at all. And his work for the days before the incidents described had been with the thresher – Mr Fulcher did not say

whether Robert was asked about this 'work' he was on his way to. But further in his statement Mr Fulcher relates that Robert said to either Mr Smith or Mr Collins (and neither had a clear recollection of this part of the conversation) that he had been on his way to Wolviston at dinner time and had the accident then. In neither Mr Smith's nor Mr Collins' statements is there any mention of when Robert's accident was supposed to have happened. In Court, Mr Paley Scott for the prosecution asked Mr Fulcher in examination-in-chief:

Question. 'Did he say when he had fallen off his bicycle?'
 Answer. 'Well, he said early in the morning at first, about 8 o'clock.'
 Mr Justice Wrottesley. 'He said at first it happened ...'
 Answer. 'At 8 o'clock. Then later on he said dinner time.'
 Mr Justice Wrottesley. 'Later on he said it happened at dinner time.'
 Mr Paley Scott. 'That would be somewhere around 12 o'clock?'
 Answer. 'Yes, he said he was in Haverton at 1 o'clock and he fell off going to Haverton.'
 Mr Justice Wrottesley. 'He said he was in Haverton by 1 o'clock and he fell off going there; was that it?'
 Answer. 'Yes, sir.'
 Mr Paley Scott. 'Did he say which day that was?'
 Answer. 'That was the day we were talking to him, the 19th.'

So it seems Mr Fulcher remembered a conversation in which neither Mr Smith nor Mr Collins recalled or mentioned in their statements. In Court, Mr Smith 'couldn't say' when Robert said he had the accident. But Mr Collins said in his evidence: 'He was asked why he had not been to work that day. But later I asked him when did the accident occur, and he said "10 o'clock". I said: "Last night?" He said: "No, in the morning."' And at 10 o'clock in the morning Robert had been preparing to *walk* to the 'dole office'.

But what the three men did decide was that Robert was 'pale', 'nervous', 'agitated' and 'not his usual self'. It is unclear what demeanour they had expected if one had just heard about the murder of a person one knows.

Finally, at the newsagent's, Mr Collins advised Robert that as he had been in Wolviston on the afternoon or evening of Tuesday 18 January then he should expect the Police to question him. He said Robert '... bloody well hoped not', but Robert denied this.

Altogether, this evidence says little, is confusing and bogged down with trivia but seems typical of the type of 'padding' the prosecution used to attempt to show Robert in a suspicious light.

But what seems to have prompted their interest is Mr Collins' observation that Robert said he was in Wolviston that afternoon and returned in the evening – in the afternoon he had been riding a bicycle and in the evening he was on the bus. Mr Collins said this made him 'very suspicious' that he had used one form of transport in the afternoon and another in the evening.

In his summing up, Mr Justice Wrottesley had this to say about the little scene at the newsagent's:

> Of course there is the suggestion that the man was giving to those three men an account of his movements the previous day which did not really square with the truth; but I think you will probably come to the conclusion that their recollection of what exactly was said is not sufficient for you to attach too much importance to what he is alleged to have said to those three men. Still more do I counsel you not to rely on their evidence as to his demeanour, because, as I have said, you were not there, and it is trusting another man's account of a third man's demeanour, and I recommend you not to rely too much upon that.

In the trial, Robert didn't give evidence, which was his right as the system relies on the prosecution to prove their case, but it is clear that all of this – what really amounts to mere suspicious events – could have been cleared up by Robert giving evidence. When he was dragged into the Police Station to 'help with enquiries' he was just that – helpful. There was no suggestion at all that he was anything but co-operative. Later he was asked to give a blood sample which initially he was willing to, but somewhere along the line he was advised not to, which was to quote Mr Justice Wrottesley '... his absolute right.' But what effect did this have on the jury?

*

Although it was a small community and people knew each other, there was a bit of distance between Robert's home and his contacts, both work and social. And as he was working in a rural area and involved in farm work, he had to travel from one place to another. It was not like changing employment from one shop to another, or one factory to another: it was one farm one day and another farm the next. So a large number of men in the story and, I expect, a lot of the woman too would rely on a bicycle to get them around.

And the reason a bicycle is topical is that Robert's machine was the subject of a part of the identification procedure. This might seem odd but if all the evidence pointed to Robert and a conclusive description of his bicycle was available then this might be sound evidence. As it was, however, it was just like events described in the last chapter, merely another vague example of a suspicious event to be tied in with the others. Nowadays the case would get nowhere near a Court but the fact it did, and against all the odds a conviction occurred and then a hanging, makes it all the more worth reviewing.

Robert's bicycle was of the racing variety with the drop handlebars. This was years before mountain bikes and their growing and refreshing popularity. So it is not clear whether it was a simple bicycle or one with a couple of 'gears' to help on upward inclines; or was one with proper racing mechanisms designed for racing.

Mr Swales, the driver of the lorry delivering the livestock, simply described it as 'a pedal cycle' and said little else in Court. Mr Nelson: 'I noticed the bicycle was a racing model and had black handlebars. The cycle shown to me at the Stockton Police office at 7.30 p.m. on 20 January is identical with the one I saw lying on the road leading to High Grange Farm ...' This might seem fairly conclusive, but under what circumstances at the Police Station did he see the bicycle – was it just one isolated bicycle, with the question: 'Is this it?' or did he see a line of bicycles and was he required to select one?

In Court though, the evidence becomes far less certain: 'identical' turns into 'similar'. In examination-in-chief, Mr Paley Scott asked Mr Nelson:

Question. 'Did you notice at all what it was like?'
 Answer. 'It was a racing bicycle.'
 Question. 'Do you mean by that that the handlebars were dropped, or what do you mean?'
 Answer. 'Yes, they were dropped handlebars.'
 Question. 'Did you see what colour the handlebars were?'
 Answer. 'No, I could not swear to that.'
 Question. 'Could you see whether they were silvered or not?'
 Answer. 'They were painted, I think.'
 Question. 'What colour?'
 Answer. 'Black.'

The problem is that this evidence does not match his earlier evidence. In his statement he said the bicycle shown to him at the Police Station (which was Roberts) had 'black handlebars' and was 'identical'. In examination-in-chief this becomes less certain but in cross-examination it becomes decidedly vague. Mr Morley for the defence:

Question. 'Can you say anything at all about the bicycle, really, except that it was a bicycle?'
 Answer. 'I just saw it was a racing bicycle.'
 Question. 'You said just now it had black handlebars?'
 Answer. 'Yes.'
 Question. 'Why did you say, in answer to the question to you first of all: 'I could not see what colour the handlebars were'?'
 Answer. 'It was dark.'
 Question. 'Why did you say just now in the witness box: I could not see what colour the handlebars were?'
 Answer. 'Well, I could not swear to that.'
 Question. 'You know that the bicycle which has been produced in court has got black handlebars, and that has led you to think that the bicycle you saw had got black handle bars: is that it?'
 Answer. 'No.'

Question. 'I do not understand what you mean when you say: 'I cannot swear to their being black handlebars' when you have just sworn that they were black handlebars; what do you mean?'

Answer. 'Well, it was a racing model.'

Question. 'I dare say, but why do you say: 'I cannot swear it had black handlebars', and yet you have just sworn they were black handlebars?'

Answer. 'Well, I saw the motor light on the bicycle.'

Question. 'Why was it that the headlights were shining to the right and not to the left?'

Answer. 'Because the bicycle was half way across the road.'

Question. 'It was a dark night at this time, half past five?'

Answer. 'Yes.'

Question. 'Did you see the dark part of the bicycle, or any silver part of the bicycle?'

Answer. 'No.'

Question. 'Can you say there was not any silver part?'

Answer. 'No, I could not swear to that.'

Question. 'Apparently that was what you were looking for – to see whether there was any silver showing. Was there any silver showing?'

Answer. 'No.'

Mr Morley. 'Let that bicycle be brought back again.'

When the bicycle was brought back into Court Mr Morley furthered his cross-examination by pointing to various parts of the bicycle and asking questions, so it would only be conjecture as to what part he was pointing to in relation to what question. However, it is not conjecture that Mr Nelson changed his description from 'identical' to 'similar' and taken with the woolly answers he gave both in examination-in-chief and cross-examination, then it was not proved beyond reasonable doubt that the bicycle he saw laying across the track leading up to High Grange Farm at about the time of, or minutes after, the murder, was the same bicycle produced in Court – Robert's bicycle.

In re-examination, Mr Paley Scott elicited from the witness:

Question. 'What you did not see was the bright silver look that it would have if they were silvered handlebars?'

Answer. 'Yes.'

So one is left with the feeling that Mr Nelson gave evidence on what he did not see – i.e., bright silver handlebars and so gave evidence on what he assumed he saw: that the handlebars were black. But there's another point Mr Paley Scott brings out in his re-examination.

Question. 'Did you see the bicycle that was brought into Court before you made your statement or after?'

Answer. 'After I made the statement.'

But if he only saw the bicycle *after* he made his statement, then how could he possibly have said in his statement that the bicycle was 'identical'?

*

So much for what the eye of the witness can tell, what about the eye of the expert and the eye of science? The two areas discussed here are not the total of the forensic or scientific evidence at all, merely they give a couple of examples. Firstly, could it be proved Robert was at the scene of the crime and, secondly, did he and Mrs Dobson have any contact or proximity to one another. So two pieces of evidence, the plaster casts DS Foster ordered to be taken from the scene of the crime and what was found on the gloves Mrs Dobson had been wearing and wore still when the body was prepared for post-mortem.

Mrs Dobson's body was found on what was referred to as 'the plough' which means a field which has been ploughed. Soil or clay will be exposed which might give good evidential opportunities.

To digress, adjacent to her body were her false teeth and her handbag, all described as being 'pressed' into the soil. This suggests at the time they were pressed into the soil, that is the time of the murder, the soil was softer than it was the following morning, and so if teeth and a handbag could be pressed into the soil then the sole of a shoe would also. Robert's shoes had been cleaned by the time the Police examined them, which proves nothing. But it still means a clear idea of his shoes and the kind of print they would make would be apparent. When the body was found, Mr Dobson himself walked around the body. But there were a couple of prints which were not Mr Dobson's. Casts were taken and produced in Court. A lot of confusion surrounded the casts which may have been because of Counsel's questions and the policeman's (DS Foster) answers. But Mr Justice Wrottesley seemed to be able to summarise things by asking for a re-cap on a previous question and answer, which the shorthand writer was directed to read. (Q: 'And, having thought it worth while to compare it with the Accused's shoes, you could find no resemblance between the cast and the Accused's shoe? A: I certainly could not, sir.') Wrottesley could then put his own question to DS Foster:

> Mr Justice Wrottesley. 'There is no doubt about it then that those marks that you got out of that ploughed field are not, as far as you can make out, the impressions of the Accused's man's boots?'
> *Answer.* 'That is so, my Lord.'

So Robert could not be placed at the scene of the crime, at any rate by his shoes. The eye of the expert is the same as anyone else's insofar as it has its limits, therefore most exhibits arrive in Court after a fairly lengthy detour from wherever, via 'the lab' to the Court. And with the various statements one can plot the passage of the exhibit and consider the evidence as it is picked up. And there are various experiments (all documented) made on the exhibits, the results of which, when given to the jury, can help them immeasurably in their deliberations. But

this is only for experiments which can be scientifically 'proven', which actually means the expert will give an *opinion* based on the findings of the experiment and what his knowledge and experience tells him, and what collective experience in his profession help him deduce. So there's no room for guess work.

Mrs Dobson's body was wheeled into Dr Cookson's lab for post-mortem examination on Friday 21 January at the Hartlepool Isolation Hospital. He was well qualified and experienced for the job and his notes are detailed, which is still helpful some seventy years later. Dr Cookson first of all had to gain access to the body to examine it so had to remove Mrs Dobson's clothes.

'The clothes in which the body was dressed were removed by me and handed to Sgt Foster of the Durham Constabulary.'

So if one traces the clothing, or some of it through the system, it is interesting to see what tales it can tell. DS Foster takes up the story:

> I took possession of the clothing as it was taken from the body by Dr Cookson. I received a pair of ladies ... brown woollen gloves ... These articles I later handed to DS Lee of Jarrow who parcelled them up for further examination.

Over to DS Lee:

> At the Police Station, Jarrow, I examined the clothing and found various stains, hairs and traces, which I noted and packed ready for examination. (para) At 1.30 p.m. on Monday 24th January, 1938, I handed the whole of the clothing and the traces collected therefrom to Dr Henry Ansty Cookson, Pathologist at Sunderland Infirmary.

So it may appear that things are going around in circles but that misses the point, it gives an insight into the conscientious way investigations are made and records kept. But it does expose the exhibits to the risk of contamination.

A pathologist will record each test he does and why. No doubt, for convenience, Dr Cookson arranged his work so he could examine the body at one time and examine the clothing another day. He would also examine Robert's clothing. But sticking to Mrs Dobson's and the example of the gloves:

> W. Brown woollen gloves – fingers bloodstained.
> X. Brown woollen glove – right – fingers bloodstained.
> (The W and X are exhibit identification.)

The gloves were an important piece of evidence. An important part of the prosecution presentation was that the scratches on Robert's right cheek were made by Mrs Dobson as she fought for her life. It was possible she might have scratched through the glove material and an experiment was set up where Dr Cookson's secretary would try to scratch Det. Supt Kirkup, but although the experiment was deemed to show that the scratch could be made, scratches

actually were not made. And if Mrs Dobson had scratched Robert then traces of wool and possibly his skin too would have been found on microscopic examination of the gloves (as below) but were not found. And Dr Cookson did not examine under Mrs Dobson's fingernails for woollen strands or skin.

None of the garments Dr Cookson examined, even when there was sufficient blood, were categorised into groups. His counterpart, Dr Roche Lynch, did group the blood: it was all group II (A).

The gloves also had a further examination by Professor Tryhorn at Hull University. Professor Tryhorn listed all of the garments he was to examine and also noted the police officer who presented the garment for examination:

W. Woollen gloves.
W1. Hairs from left glove.
W2. Debris from left glove
X. Brown woollen glove, right.
X1. Debris from right glove.

His abridged report said:

The following exhibits gave on [sic] significant results on examination: Exhibits … W, and X (debris from Mrs Dobson's clothes) Nothing significant was found in these; they consisted chiefly of soil and dust particles, unidentified vegetable matter and fibres derived from the various garments.

In short, no animal cells, i.e., skin from Robert's face or animal fibres from the woollen gloves. So it is not proven that Mrs Dobson's fingernails had contact with Robert's face.

However, as mentioned above, there was a third forensic report about the blood on the garments from a Dr Roche Lynch for the Home Office at Paddington Hospital, but the gloves were not examined.

So that leaves the consideration of how the prosecution used the evidence of blood on the gloves in Court. In examination-in-chief the gloves were not referred to, neither were they in cross-examination. Mr Paley Scott re-examined Dr Cookson's evidence:

Question. 'Now there is one matter I'm afraid I omitted to put to you that I ought to have put to you. You have told us you took from the deceased woman's hands a pair of knitted woollen gloves?'
 Answer. 'I did.'
 Question. 'I wanted to know this. If any person wearing those gloves was trying to fight a person off like that (illustrating), would that person make marks on the face with the finger nails?'
 Answer. 'They could do.'
 Question. 'Although the gloves were being worn?'

Answer. 'Yes.'

Question. 'Why do you say that?'

Answer. 'Because they are a sort of knitted network and they spread out at the ends, allowing the fingers to come through the mesh of the worsted.'

Question. 'Have you experimented?'

Answer. 'Yes, I have.'

Question. 'On whose hands did you put them?'

Answer. 'On my lady secretary's hands'.

Question. 'And whom did she try to scratch?'

Answer. 'Supt Kirkup.'

Question. 'Did she succeed in doing it?'

Answer. 'She would have done if she had persisted.'

Question. 'He felt the nails?'

Answer. 'Yes.'

Mr Justice Wrottesley. 'Did you examine the dead woman's fingers?'

Answer. 'Yes, my Lord.'

Question. 'Had she noticeable nails? Some people have hardly any finger nails.'

Answer. 'They were of quite the ordinary length, prolonged at the bulb of the finger.'

Question. 'Nails such as could inflict the scratches you have heard about?'

Answer. 'Yes, my Lord.'

Question. 'Through those gloves?'

Answer. 'Yes.'

Question. 'Enough to mark a man's face?'

Answer. 'Yes.'

Mr Morley. 'My Lord, may I ask a question on that?'

Mr Justice Wrottesley. 'You can ask about that, Mr Morley.'

Further Cross-examined by Mr Morley.

Question. 'When did you examine the dead woman's nails with this in mind?'

Answer. 'Only a part of the general post-mortem examination one always makes in criminal cases.'

(The question was: '*When* did you' The answer was of routine. But DS Lee realised the importance of the fingernails as he had noted Robert 'bit' his. So it seems an omission – perhaps not deliberate – and a strong evidential opportunity was missed.)

Question. 'When you gave evidence about the results of your post mortem examination did you make any reference to her finger nails?'

Answer. 'No, I do not think I did.'

Question. 'You conducted an experiment by the hand of your secretary on Supt Kirkup. The experiment seems to have terminated before the result was achieved, did it?'

Answer. 'Yes, it was clearly foreshadowed what the result would be.'

This is an assumption by Dr Cookson rather than a proven fact. The assumption is more akin to guess work than science. And he did not examine under Mrs Dobson's fingernails. Dr Cookson said: '... it was clearly foreshadowed what the result would be.'

There are no details of this experiment and the circumstances in which it took place: for instance, was Det. Supt Kirkup punching the lady secretary in the face/head as Robert was alleged to have done, and was he trying to bundle her off into a field?

In further cross-examination Mr Morley pursues the point.

Mr Morley. 'Some secretaries, of course, have long and elegant finger nails, and not many old ladies, farmer's wives of sixty-seven, have very long finger nails, have they?'

Answer. 'I do not think in this case there would be any gross difference.'

Question. 'Have you examined these gloves?'

Answer. 'I have seen them.'

Question. 'Do answer the question. Have you examined them?'

Answer. 'I have seen them.'

Question. 'Well, does 'examined' mean the same as 'seen'? I know you have seen them because I have watched you looking at them. Have you examined them?'

Answer. 'Yes.'

Question. 'Did you find any sign of damage or interference on them?'

Answer. 'No, there is practically no damage on them.'

Question. 'Would you not expect, if someone had been scratching a face with it, leaving scratch marks down it, to find some sign of blood on it?'

Answer. 'I think there is some blood on it.' ('... think')

Question. 'I just asked you if there was any sign of damage. Is not blood a sign of damage on a glove?'

Answer. 'No.'

Mr Justice Wrottesley. 'You think there is blood on them?'

Answer. 'Yes, my Lord.'

Dr Cookson 'thinks' there is blood on them. The contention that there was any contact or proximity between Robert and Mrs Dobson has not been proven. And for discussion later will be other issues where contact between Robert and Mrs Dobson cannot be established.

So it can be demonstrated there was neither proof Robert was at the scene of the crime or that there was contact or proximity between Robert and Mrs Dobson.

*

So to Robert's clothing – just what was Robert wearing on the afternoon of the murder? It was established by the Police that the clothes he wore when he was brought into the Police Station on the Thursday night were the items he wore on the day: fawn raincoat, brown jacket, brown waistcoat, grey flannel trousers, blue overalls, brown shoes, fawn cap. There were mixed recollections as to whether he wore a cap or a trilby, but it was the cap that got the casting vote.

At the Police Station, Robert made his statement and the Police asked if they could take his clothing for examination – he agreed. He changed into some other clothes the Police brought from his home. Blood was found on several garments which Robert could not account for, so they went for scientific examination. He did not know his own blood group but had no objection to giving a blood sample – this consent he later withdrew. DS Lee collected his clothing to be sent off.

The Police also obtained some items from Robert's home – he had recently a boil on his neck which had burst so his bedding was examined. And a handkerchief was found with blood on.

Also at his home, in a waistcoat, a pocket knife was found which belonged to Robert. This was clean and the suggestion was that this was the murder weapon, which he had cleaned thoroughly after the murder. On examination, a minute trace of blood was located in the nail groove of the blade. This knife was subjected to numerous tests but was never proven to be the murder weapon.

Dr Cookson provided a detailed report of Robert's clothing. (This makes the slap-dash information on Mrs Dobson's gloves even more confusing.) Red stains were found on the fawn raincoat and on the waistcoat, but these were not blood stains. Blood was found on his cap, overalls, trousers, jacket, shirt cuffs and handkerchief. From his home, the bolster case also showed blood – the amount was insufficient for grouping. Also insufficient for grouping was the blood found on the cap, overalls, trousers and jacket. (The blood on the shirt sleeves and the handkerchief were group II (A) which is the blood group of between 38 and 40 per cent of the population; and just happened to be Mrs Dobson's blood group.)

Dr Roche Lynch was in almost entire agreement with Dr Cookson's opinions on the incidence of group II (A) at about 40 per cent of the population. But the two men gave differing and somewhat conflicting views as to the location of the bloodstains: the brown jacket Robert wore fell into a list of garments Dr Cookson examined but did not find any blood on. Dr Roche Lynch on the other hand found the following on the jacket:

On the bottom of both sleeves on the inside human blood has been detected. There was not sufficient blood present for the group to be determined. The quantity of the blood is small but there was more blood on the right sleeve than the left.

In Court, the jury heard Dr Roche Lynch give evidence during Mr Paley Scott's examination-in-chief:

Question. 'Would that correspond or not with the blood stains in the shirt cuffs?'
Answer. 'Yes, sir, it corresponds in two ways: one, by position; and the fact that the right shirt sleeve has the greater amount of blood on it, so has the right jacket sleeve; and similarly with the left sleeve.'
Question. 'If blood came on the cuff, for instance, while it was out and then it were drawn into the coat, that would make the sort of smears you found on the coat?'
Answer. 'Precisely. They were very slight smears and so slight I could not determine their group.'

It is interesting: Dr Roche Lynch found blood where Dr Cookson did not. Dr Roche Lynch does not list Mrs Dobson's gloves among the garments he examined. In his report, Dr Cookson does not mention the gloves Mrs Dobson was wearing when she met her death, nor does he report any examination of them, which makes one wonder the basis for his assertion in Court, that he saw blood on the gloves. And as discussed, he was reluctant to give Mr Morley a straight answer in cross-examination:
Question. 'Have you examined these gloves?'
Answer. 'I have seen them.'
And so on.
But he does not mention them in his report and in answer to Mr Morley as to whether he saw blood or not on the gloves he said, 'I think there is some blood on it.'
The other difference between Dr Roche Lynch and Dr Cookson was that on the cap (Robert had two so this relates to the one he is assumed to have worn on the day, designated exhibit 9). Dr Cookson's report said: 'There was a human bloodstain on the edge of the *right* side of the peak of the cap' (author's italics). Dr Roche Lynch said that on the *left* side of the peak of the cap human blood was found. DS Foster said the blood was on the right side – if the right side of, say, a jacket is that which is to the right of one's body when one wears it, then the right side of the cap is over the right side of one's head. Dr Cookson said in answer to Counsel that there was, on the cap, an 'appreciable amount' but the blood was not grouped; Dr Roche Lynch said there was too small an amount of blood on the cap for grouping. It is one thing for two expert witnesses to hold different opinions, but this demonstrates they made different observations.
When Robert was interviewed by the Police, they related to him the places blood had been found, but he could not account for it. DS Foster had brought a change of clothing from his home.
Robert did say he cut himself shaving on the Tuesday (18 January) evening but it is unlikely this blood was what found its way onto his shirt cuffs. The

fact that some of the blood had been propelled towards the shirt, rather than just dripped on it militates against the shaving theory.

The handkerchief had blood of group II (A). As blood had been found on the pocket knife, a suggestion was that Robert had cleaned the knife with the handkerchief after the murder. This was not proved, and if Robert had been the culprit and he cleaned the knife as conscientiously as he is supposed to have, then it does not make sense that he did not try to dispose of the handkerchief. It is doubtful that the knife, which was forced into the victim right up to the hilt, (the force of the thrust may well have been what cracked one of Mrs Dobson's ribs) and when withdrawn had drawn some tissue out with it, would have been cleaned so completely as to remove all evidence. Unless the knife was dismantled it is difficult to see how blood or tissue could have been removed from the hinge of the knife – effectively the hilt of a pocket knife when it is opened.

The blood found on the overalls and the trousers could not be grouped as the amount was so small. However, it did correspond in area, around the fly.

Robert was initially willing to give a blood sample, though he later withdrew this consent. All of his clothes he gave willingly to be tested, and he also gave all the details of where his alibi could be checked (except Mrs Teale, who he probably did not know about). So this does not sound as though he behaved in any way suspiciously whilst in police custody. It was thought one of the lawyers advised him against giving a blood sample.

The forensic evidence surrounding the blood did not prove Robert had murdered Mrs Dobson. As an agricultural or manual worker there may have been times when he had cuts or abrasions on his hands that had well healed; and there was no indication as to how old the bloodstains were. It was only the grouping that was anywhere near suggesting a link to the murder, but with about 40 per cent of the population sharing the same blood group as Mrs Dobson, one of whom could well be Robert, this is hardly conclusive.

The blood patterns on the sleeves of the shirt were described by Dr Roche Lynch and Dr Cookson. Both sleeves were stained – the right more than the left. But both had smears as well as drops of blood. The smears corresponded to the blood found on the inside of the sleeves of the jacket and could have been the result of 'wiping'. The droplets though were what was called 'travelling blood' – they had travelled from point A (cut on someone's body) to point B, the sleeve of Robert's shirt. But the question for the Court was: what had propelled the blood? Robert said he had cut himself shaving, which suggests gravity had propelled it – this was thought unlikely. But when someone is stabbed and the knife is withdrawn, blood can be propelled this way – but just how far it will travel is another question. If a victim is upright or even above the attacker, blood will travel far more readily than if a victim is on their back; although it was not clearly analysed by the experts at the time, it was thought that the two fatal stab wounds were made after the rape. Mrs Dobson was positioned on her back at this point – her attacker would have been above her, and therefore the travelling distance would not have been great but quite

possibly the withdrawal of the knife may have flicked blood up onto the sleeve of the arm of the hand he held the knife with. However, it is unlikely this would have flicked onto the other or free hand unless he held a small pocket knife with both his hands, but this seems unlikely.

There was no suggestion that Robert had attempted to clean his working clothes for several days prior to the clothes being taken for examination. Therefore, the removal of any bodily fluid evidence could not have been made or even attempted to remove the semen stains, which would almost certainly have been present and clearly visible on his trousers and overalls.

In fact, there was a complete absence of semen stains on these garments.

There was never any suggestion that one person had raped Mrs Dobson and another had murdered her. So the absence of staining on Robert's trousers and overalls was inexplicable unless he had not been guilty of the offence. The trousers had a fly opening as did the overalls, so there are two methods the attacker could have adopted, but do bear in mind this is on a January afternoon in the middle of an exposed part of rural Durham.

Firstly the trousers and overalls could have been pulled down or completely removed. As they were bib and brace overalls then his jacket and overcoat would have to be taken off too, if not to pull down or remove the garments, then certainly to put them on or adjust them afterwards. This is unlikely due to the cumbersome nature of clothing rearrangement, the climate, and the possibility of any witnesses travelling the path.

Secondly, then, the alternative is that he would keep his clothes on and make the sexual connection via the fly. But this is equally unlikely. It would have taken his overalls into direct contact with Mrs Dobson's genitalia which were described later: 'The hairs were matted and swabs were taken from these and showed spermatozoa.' Yet no spermatozoa shed on either the overalls or the trousers, inside or out. But also Robert's shirt had front flaps and these too yielded no incriminating evidence of spermatozoa. So this goes back to him removing his clothing, but still spermatozoa may well have been on his penis and would therefore deposit itself on the inside of his overalls, or more likely his trousers when he adjusted his clothing.

Either way, the forensic evidence did not establish a link between Robert and Mrs Dobson and if anything the link was further marred by Dr Cookson and Dr Roche Lynch giving conflicting evidence as to the blood on his cap, or the absence or presence of blood inside the sleeves of his jacket.

Some clay specimens were found on Robert's clothing which were inconclusive as to their origin.

However, some hairs were found, notably on Robert's handkerchief, which were compared with hair known to come from Mrs Dobson. Professor Tryhorn said:

'... I compared these hairs microscopically in regard to texture, colour, structure, pigmentation, and surface markings.' They were said to be a close match and would lead Professor Tryhorn to suggest the hair from Robert's

handkerchief could very well have come from Mrs Dobson's head, but this fell short of proof. In fact it is, or was at that time, difficult if not impossible to give conclusive evidence on hair. Mr Morley established in cross-examination:

> Question. 'And I take it that though you found many characteristics – well, all the characteristics you have mentioned – in common between the two samples, you would not be prepared to swear, would you, that any of these hairs had come from any particular source?'
> Answer. 'No, I would not.'
> Question. 'I mean, it is terribly difficult with hair, is it not?'
> Answer. 'I think it is impossible.'
> Question. 'And all your evidence really amounts to is that they might have come from there or might have come from there?'
> Answer. 'I agree with that. I cannot indicate the probability.'

In his summing up the Mr Justice Wrottesley concluded that the forensic evidence did not prove anything:

> ... I think it is best to describe that by saying it does not amount to proof. It only proves that there is nothing inconsistent found – nothing in regard to the blood or in regard to the hair which is inconsistent with this man being the murderer. That, of course, is not the way in which guilt of a crime like murder is established; you have to go further ...

There are some lawyers who feel forensic evidence is not as conclusive, even today, as it is claimed to be. Some notable recent examples are given by Mr Outerridge in the case against Stephan Kiszko, and Sir Roy Meadows in the case of Sally Clarke, both of which convictions were quashed. Mr Outerridge was to face criminal proceedings but the Magistrates complicated matters, so he didn't; and Sir Roy Meadows was actually struck off the medical register for his claims. Another, Dr Doothwaite in the case against Dr Bodkin Adams, fell into ridicule after cross-examination.

*

All too often in a criminal case, especially when there's doubt involved, the Police are put 'on trial'. The Police have their methods – probably better today than they were in Robert's day – which, if they do not fall into the victim's perception of how the Police should be investigating, leads to criticism. If they get the wrong man, they are accused of incompetence and if they get the right man, well they didn't get him soon enough. Some highly publicised cases have not helped the Police's reputation but it is true that every copper on every 'beat' has to carry the stench of bad copper with him. Perhaps the issue is best summed up that, to borrow someone else's phrase: 'if the Police do something right, no one remembers; and if they do something wrong, then no one forgets.'

But, in the case of Rex v. Robert Hoolhouse, the Police seem to have acted properly and professionally throughout, although there are a couple of errors in their facts – some of these should have been picked up in the course of the trial by the defence. But there does seem to be a genuine feeling that Robert was the culprit. And there are a few issues where the Police can be demonstrated to have acted with integrity which should be highlighted.

The case was overseen by Det. Supt Kirkup, but the day-to-day Police activities were coordinated by DS Foster. In overall command for the CID side of things in Durham in those days was Assistant Chief Constable Robert Gardiner.

Det. Supt Kirkup wrote:

> A man named Bert Husband will state he saw the prisoner at Hope Street, Haverton Hill, at 4.05 p.m. on the afternoon of the 18th January 1938. And Mrs Doris Teale, of No 5 Pickering Street, Haverton Hill, will state she saw prisoner at his home between 4.30 and 5 p.m. the same day. These statements are contradicted by the times he is stated to have left Wolviston, by Miss Lax and Miss Husband, and also Thomas Bell, who states he saw the father of the prisoner locked out of his house at 4.45 p.m. on the 18th January 1938 and that the father asked for the keys of the house.

Det. Supt Kirkup says '... these statements are contradicted ...' The Police had to get, and relied on, the evidence of Dorothy and her aunt, Beatrice, because they said Robert wore a cap and the man seen at the scene of the crime by Mr Swales and Mr Nelson wore, they said, a cap. And at that time the cap in question had been found to have blood on it.

However, taking things in turn.

Bert Husband was riding home in company with a colleague. The colleague said the day in question was not the 18 January, it was the 19th.

Doris Teale said that 'Between 4.30 and 5.00 p.m. ... I was busy cleaning my bedroom upstairs I went to the back bedroom window And I saw Robert William Hoolhouse ...' It is not implicitly stated Mrs Teale went to her back bedroom at 5.00 p.m., but if she was cleaning from 4.30 to 5.00, it suggests it was closer to 5.00 p.m. that she went into her back bedroom. Contrary to what Det. Supt Kirkup says, this actually complements what Dorothy and her aunt say; it does not contradict it.

Robert's father arrived home from work at 4.45 p.m. and Robert was not in the house. (The Hoolhouse family actually had a hiding place for a spare key.) But this does not say Robert was not in the house at 5.00 p.m., it says he was not in the house at 4.45 p.m.

So could Robert have been in the house at 5.00 p.m.?

He left Dorothy and her aunt at, they said, 4.40 p.m., was seen by Mrs Teale somewhere between 4.30 and 5.00 p.m., and PC Chapman timed the ride on a bicycle from outside Dorothy's home in Wolviston to Robert's home in

Haverton Hill as 20 minutes. If Robert left Dorothy's house at 4.40 p.m. then it is perfectly possible that he could have been home at 5.00 p.m.

At the time Mrs Teale saw Robert in the back garden of his house she also saw a train entering Haverton Hill station, and then it moving on south towards Port Clarence. The 1937-8 timetable for the London and North Eastern Region list a train coming from Middlesbrough via Haverton Hill and on to Port Clarence. This would have been a passenger train and was due to arrive at Haverton Hill that afternoon at 4.49 p.m. The train is unlikely to have been early and if it was it would not depart until the appropriate time – two minutes later. As to whether the train ran late or not is not known. It would have been helpful if the Station Master or Signalman at Haverton Hill Station had been questioned.

Of course, providing the reasonable doubt is more, but not wholly, the job of the defence lawyers than the Police.

Det. Supt Kirkup does mention Mrs Teale and also Mr Burns – the third man in the lorry delivering livestock to High Grange Farm – two of the men in that lorry saw the stranger on the farm track, but Mr Burns said he did not. So by the time Det. Supt Kirkup is reporting to his superiors, Mr Burns has not been removed from the evidence.

But Mr Burns is not on the list of witnesses the ACC, Robert Gardiner, prepared. But the fact remains, Mr Swales and Mr Dobson said in evidence under oath in Court that there were two men on the lorry.

Det. Supt Kirkup is also mistaken in another fact, he wrote referring to Robert:

> It was then found out that he had been employed by the Dobson's in 1933 and that there had been threats used by him at that time towards the Dobson's, and eventually the police had to be called to have the family turned from the premises, and instructions were given that they were not to be allowed there again. [sic]

There are a couple of points to this. It was Robert's father who had come into conflict with Mr Dobson – it is unclear what the issue was. And according to Mr Dobson it was Robert's father who had threatened him. Apparently Robert had stood by and had not contributed to the confrontation. Mr Hoolhouse senior did have a police record for assault and was said to be hot-headed. So Robert was sacked as an 'accessory'. And over the five years Robert had gone back to the farm a couple of times looking to work casually, mainly related to the thresher team. And he actually admitted he had seen Mrs Dobson about a job in mid-December 1937 – so did Robert know about this blanket ban by Mr Dobson on the Hoolhouse family? Five years is a long while to hold a grudge and there's no evidence there were any issues in the meantime. The Hoolhouse family appear to have settled and found work, and at the time of the crime Robert was hoping to join the Post Office. So the logic does not quite fit. But it does not demonstrate any malpractice by the Police. It all seems genuine.

At the time of referring the case to the Director of Public Prosecutions, ACC Mr Gardiner was in written and verbal communication with the DPP. And a list of names of witnesses was furnished. Bert Husband's name is crossed out, which seems quite reasonable. But Doris Teale's name is also crossed out – not left off the list, Mr Gardiner included her; but someone decided her evidence was not to be put.

And this has to prompt the question as to whether this served the interests of justice. Doris Teale saw Robert in his back garden at just the time he would have expected to have got there if he left Dorothy at the time she said. This means, quite simply that he could not have been on the farm track to murder Mrs Dobson.

One possible line of argument here is that after Robert had got home he decided to return to High Grange Farm after 5.00 p.m. But Mrs Dobson left the farm house at just after 4.30 p.m. and with the approximations as to how long she would have taken to travel the farm track, then even by the widest margin she would have cleared the track by 4.50 p.m.

Robert may have gone to the track and been seen by Mr Swales and Mr Nelson. But their description was the man was thirty (Robert was twenty) wearing clothing Robert did not possess.

With consideration of all of these variables, it seems likely that if Robert left Dorothy at 4.40 p.m. and it was a twenty-minute cycle ride home, then he went straight there as he has an independent witness. It seems unlikely he would have been on the farm track, aged ten years and wearing clothes he did not possess. As to whether the sacking of the family by Mr Dobson five years before provided Robert with a motive to rape and murder is open to debate. The Police thought it was and this does not take any merit away from a clear, but flawed investigation.

*

Mr Charles Dickens encumbered Mr Thomas Gradgrind dreadfully with Facts. And he would have been bewildered by the sheer volume of facts in the case of Robert Hoolhouse. But facts that changed.

Det. Supt Kirkup noted that Robert, on 18 January, stayed with Dorothy for '... about an hour. He then left on his bicycle and nothing more is known about his movements until 6.45 p.m. ...' But he was seen at his home by his father and also by his neighbour; and incredibly this is recorded by Det. Supt Kirkup in the very same note!

Also Det. Supt Kirkup comments, '... he had been employed by the Dobson's in 1933 ... there had been threats used by him ...' But according to Mr Dobson's statement, it was his father who made the threats; Robert had said nothing.

A lorry delivering livestock had three men initially, but one of the men seems to have been extracted from the evidence.

Communications were not good in the Police Station as Bert Husband changed his story. Initially he said he had seen Robert on 18 January, but his

workmate questioned the date. He then changed his sighting to the 19 and not the 18th, but nobody seemed to inform Det. Supt Kirkup.

Fortunately, by the time Mrs Teale saw him, Robert had removed his cap – or trilby. Her time was not something that fluctuated either.

Going back to the earlier part of the afternoon, the time he arrived at the Blue Bells Inn was an approximation, but his departure time was presented as evidence in Court by Mr Walter Nelson. He said Robert left the Inn at 2.45 p.m., which Mr Nelson knew '... for a fact.' But in his statement earlier, Mr Nelson had made a comment about Robert's departure from the Inn: '... Hoolhouse and I left. It was then 3.00 p.m.' If he knew '... for a fact' that Robert left at 2.45 p.m. one wonders about how he noted the time in his earlier statement.

Ronald Baldry said in Court that on that afternoon he wore a wristwatch. Yet the time that he arrived in Wolviston was noted to be 3.25 p.m. in his statement, but 3.35 p.m. in Court.

As for Mr Dobson's timing of events, he was either incorrect or contradicted himself about various parts of his evidence. I shall look at his evidence in detail a little later.

Mr Paley Scott would have had to read the statements of Mr Dobson; and also Mr Swales and Mr Nelson coming from the livestock market at Sedgefield. There was another man on the lorry, but in his opening speech Mr Paley Scott said there were two men, and this 'fact' was confirmed in evidence by Mr Dobson and Mr Swales.

The list goes on.

In his summing up, Mr Justice Wrottesley said 'Before a man can be convicted of a criminal offence in this country a jury of twelve men or women must all be satisfied that the man has been made out on the evidence beyond all reasonable doubt.' How can the jury possibly do that if the evidence has changed? How this fits in with the concept of a fair trial involving the truth, the whole truth and nothing but the truth is equally as unclear. In fact, there was *no* evidence that Robert had been at the scene of the crime, nor any evidence of proximity to Mrs Dobson and a lack of forensic evidence that he had any sort of sexual connection in the trousers and overalls he wore that afternoon. So not only did the evidence change, there was also no proof.

Referring again to Mr Justice Wrottesley's summing up, he said of the timing of the afternoon's events by Mr Dobson: '... of course, the times are not correct times. You may very well think that in that particular Mr Dobson was not accurate in his memory ...' This is more than charitable. But when the judge refers to Robert's memory of the times he visited Dorothy on the afternoon of the 18th the words are different '... that is obviously not true.' In his courtroom, it seems satisfactory for Mr Dobson to change times, get his facts wrong and contradict himself. But when it is Robert, then it is a case of telling the jury that what he said was '... not true.' This more than suggests a bias from the judge. And the reason it is relevant here is because in the next couple of points

a consideration can be made of the trial and Mr Morley's submission – in the absence of the jury – that there was no case for Robert to answer, and it would be unsafe for the jury to consider the case. It might have been equally as unsafe to let the lawyers consider it.

In none of the documentation is there any mention of an identity parade for Mr Swales and Mr Nelson to identify Robert as the man they saw at the scene of the crime on Tuesday 18 January, but Mr Nelson said the bicycle he saw at Stockton Police Station, which was Robert's, '... at 7.30 p.m. on the 20th January is identical to the one I saw lying on the road leading to High Grange Farm.' It had, he said, black handlebars. In Court, this changed too.

But going back to Mr Dobson's evidence, he was badly mistaken in three pieces of evidence – the arrival of the thresher party (examination-in-chief), the lorry with the livestock arriving (cross-examination) and the fact there were three men and not two on the lorry (examination-in-chief). So, if Mr Dobson got this wrong, one has to ask, what else did he get wrong? There are some peculiarities to other parts of his story, which I will come back to. First we know he got back from Sedgefield market at about 2.30 p.m. because one of his 'hinds' was with him – Thomas Adams. He probably went in for tea with Mrs Dobson at about 3.15 p.m. because John Sedgewick met him as he was going into the farmhouse. Mr Dobson said Mrs Dobson came into the yard at about 4.30 p.m. and shouted down to him that she was about to leave, yet none of the other five or six men in the yard saw her after about mid-morning. It is likely she set off for the village at about 4.30 p.m. or the shops would have been closed. We know if Mr Swales and Mr Nelson's evidence is credible, that it was not Mr Dobson at the scene of the crime at 5.30 p.m. when they arrived from Sedgefield market with the livestock.

However, the story he relates of how he found his wife's body is strange – he was going into Wolviston to make contact with his daughter in Newcastle to see if she knew anything (High Grange Farm did not have a phone). He took a shortcut across a field to the north of the track which gave him a view he would not otherwise have had of a field to the south of the farm track. He saw an indistinguishable black bundle, further investigation revealed it was Mrs Dobson. But it is unlikely, with consideration as to what was seen the previous afternoon by Mr Swales and Mr Nelson, that he had anything to do with his wife's murder.

The whole case and how it is considered here relies on statements and the recorded verbal evidence given in Court. There are discrepancies and contradictions in the records, but the irony is that what the documents demonstrate above all else and clearly is that the evidence does not point to Robert as the killer.

*

The trial took place in Leeds Town Hall over three days: 28, 29 and 30 March 1938. The shorthand writers did not record prosecution Counsel's opening address to the Court, but most of Mr Justice Wrottesley's notes have survived and he notes the prosecution's points Counsel outlined:

> Mr Paley Scott introduced Robert by his age and occupation and that he was charged with Mrs Dobson's murder.
>
> There was an outline of the events for 18th January, the day of the murder. He details Mrs Dobson's tea with her husband at 4.00 p.m. and by 4.30 p.m. she is dressed to go out. She didn't come back. Mr Dobson went down the farm track a few times that evening to meet buses his wife might have travelled back on, but she did not show up. Mr Dobson sat up all night and started work at 5.00 a.m. By 10.00 a.m. the men were all working on the farm and there was a bit of a lull in activities, so he decided to go to the village and investigate; on his way he discovered his wife's body. Mrs Dobson was fully clothed, but her clothes had signs of interference; she lay on her back with legs parted, and there was evidence of male semen. There was extensive bruising to her face. Mr Paley Scott informs the jury that Mrs Dobson must have died within an hour and a half of tea – he said her false teeth and handbag were pressed into soil nearby. Mrs Dobson had been battered past resistance and stabbed twice. About 5.00 p.m., two men in a lorry turn into the farm drive.

Unfortunately, the next page is missing, but if Mr Paley Scott got his facts right he would tell the jury what the men saw – a man standing in the plough at approximately the spot the body was later found. Mr Paley Scott outlined what the man in the plough was wearing and the bicycle. And also what the men said shortly after when delivering the livestock on the farm.

On the next page he takes up the story with Robert's activities for the afternoon: Mr Nelson in the Inn with the Landlord and his wife; Robert's cycle ride into Wolviston with Mr Baldry. His visit to Dorothy and Beatrice. When he left he was 'expected' to see Mr Smith about threshing work.

Mr Paley Scott tells the jury of Robert's departure from Dorothy's house: 'If he turned south from Wolviston he would pass High Grange Road and he may have been turning up to find out about threshing.'

Then he fast-forwards to Robert boarding a bus that evening when he is on his way back to Wolviston to meet Dorothy and they go to the pictures. On the bus is a man Robert knows from the Post Office, and a lady he knows from the village.

On the 19th, he relates another visit Robert made to see Dorothy, and a little later the encounter with Messrs Smith, Ervin and Collins at the newsagent's. Robert, explained Mr Paley Scott, told them he had been to Wolviston the previous evening and met Dorothy. Mr Paley Scott made the big announcement that Robert made no reference to the afternoon visit to them of the 18th to Wolviston.

That night or early the next morning (Thursday 20), Robert is taken to the Police Station and makes a statement, gives over his clothes for examination, agrees to a blood test and gives other samples (hair). Robert essentially said in his statement that he left Dorothy at 3.30 p.m. and went home via Cowpen Bewley (away from High Grange Farm). In the prisoner's waistcoat pocket, said Mr Paley Scott, was a knife. And there was evidence of blood on his clothing.

There, Mr Paley Scott concluded his opening address.

So what was it in these facts, with the evidence to be related by the witnesses that would give the jury no room for doubt that Robert murdered Mrs Dobson? Dealing with Mr Paley Scott's opening address first, there's no doubt that this was murder; as to whether the men in the lorry delivering the livestock actually saw the murderer is a matter for conjecture, but with the way they describe his behaviour, it is hardly consistent with innocence.

But already Mr Paley Scott has shifted the emphasis of the afternoon of the murder – Mrs Dobson had tea earlier than he said. And there were three men on the livestock lorry not two. But if he was saying this before Mr Dobson, Mr Swales and Mr Nelson gave evidence, which is what he was doing, then he must have known the witness evidence would concur. So perhaps this does not shift emphasis on the evidence, it changes it. It is possible evidence can change, insofar as recollections can re-focus. But it seems far too much of a coincidence that Mr Paley Scott would say there were two men on the lorry and Mr Swales and Mr Dobson would concur.

To digress, it has often been argued by the Court of Appeal that the jury actually see all of the witnesses and can hear their evidence and decide who is telling the truth and who is not telling the truth. That's how they wriggle out of some appeals. But what if Counsel strays from the truth? The question for the Court of Appeal then would be, how can a jury decide what witnesses are telling the truth or otherwise if Counsel both shifts the emphasis of evidence (tea, for example, was at 3.30 p.m., not 4.00 p.m.) and then blatantly lie to get rid of a witness whose evidence doesn't accord with two other witnesses to the same event – three men on the livestock lorry, not two.

And to take this a stage further, who briefed the witness to play along with it – only Mr Swales and Mr Nelson in the lorry, not John Burns.

So, with this remarkable foundation, the prosecution then start to think about building their case. An architect produces some line drawings of the area, and a photographer produces his evidence.

Mr Henry Dobson is called next and tells the Court what he remembered happening. In cross-examination, Mr Morley doesn't shy from asking him about the relationship he had with his late wife. But all seemed well.

Percy Swales and Thomas Nelson deliver the pre-arranged lies and give a description of the man they saw as a lot older than Robert, wearing clothes he didn't possess. It was true Robert had had a pint or two of beer that afternoon but they said the man told them of having 'one over the nine'. (Though Robert did say on the bus later that evening to the postman that he was recovering

from a 'hectic afternoon' on the beer.) Robert's bicycle had black-painted handlebars, but in cross-examination the best these two witnesses could offer the Court is that the handlebars were 'not shiny'.

PC Chapman relates how he was shown the body by Mr Dobson together with Dr Craven (who appeared next and corroborated) and set the Police activities in motion.

Walter Nelson is next in the witness box describing how he arrived at the Blue Bells Inn half an hour later than the time he gave in his police statement, and how Robert left a quarter of an hour earlier than the time he gave in his police statement.

Ronald Baldry though was wearing a wristwatch, but his time of parting from Robert later that afternoon in Wolviston changed from 3.25 p.m. to 3.35 p.m. And the saga of the cap or trilby is reprised.

Dorothy Lax and Beatrice Husband follow next. They seem very genuine and cannot be shaken with what they say in their evidence. Robert left them at 4.40 p.m. on the 18th. (Sadly Mrs Teale wasn't called to say she saw Robert at home twenty minutes later; nor was she able to tell the Court of the train she saw – assuming the Police may have looked at movements of railway traffic – and PC Chapman wasn't asked to relate how he'd measured the time it would take to get from Dorothy Lax to home – twenty minutes. The missing alibi is sound.)

When Robert went back to Dorothy later – acting like his usual self – he went by bus where Arthur Nicholson, the postman, rode with him.

Mr Paley Scott called Bertram Smith, Herbert Collins and James Fulcher to give the damning evidence that Robert was not his usual self at the newsagent's when he had just heard of the murder. And Mr Morley, expertly in cross-examination, determined they all three had only heard snippets of conversation about Robert falling off his bicycle – that might 'shake him up too'. One wonders if Messrs Smith, Collins and Fulcher can be acutely normal when hearing of the murder of a woman they know whose farm they'd been working on that very morning. And they can be acutely normal too when Robert tells them he's fallen off his bicycle. But when Robert says he was at Wolviston the previous afternoon on his bicycle and went to the village by bus in the evening, Mr Collins becomes almost hysterical with suspicion.

The Police were fairly well represented. PS Farthing told the Court that he went to the scene of the crime with PC Chapman, Dr Craven and Mr Dobson. He took various measurements and stayed with the body pending the arrival of the CID.

PC Joseph Hodgson had brought Robert in for questioning following the attendance at the Police Station of Mr Smith and Mr Collins. He could relate how cooperative Robert was.

DC James Crossley introduced the CID, and at this point Robert's statement was read out to the Court. His clothes were taken for examination and DC Crossley is one of four officers who gave evidence that Robert could change his clothing without any difficulty – when he'd fallen from his bicycle on the Tuesday evening, he said he'd injured his shoulder.

Insp. Proud provided the continuity between the uniformed branch and CID; between the scene of the crime, Robert's interrogation and with the collection of the various items later to be exhibits: after they'd been examined.

DS Lee took some photographs. He also examined both Mrs Dobson's and Robert's clothing noting the various staining. He coordinated the dispatching of the various portions of the evidence to the scientists.

DS Foster took an inordinate amount of time to tell the Court there were two distinct footprints at the scene of the crime, from which he took plaster casts. One of the footprints was Mr Dobson's and the other was not Robert's. He also inadvertently demonstrates that the ground was hard on the Wednesday morning when Mr Dobson, Dr Craven and, no doubt, various policemen walked on it, and therefore footprints were unlikely to be clear. But on the Tuesday afternoon, at the time of the murder, the ground was soft enough for Mrs Dobson's handbag and false teeth to be pressed into it. This does make one wonder: if Mr Dobson's footprint was about the only one possible to positively identify and the other footprints (made the night before, probably by the murderer, when the ground was soft enough to have a leather bag pushed down in it) were not identifiable, then were the footprints made when all the assumptions said they were made? Or was Mr Dobson's made earlier?

Mr Dobson was recalled, but not to be asked *when* he made his footprint, and DS Foster was recalled. And still they couldn't make the footprint belong to Robert.

Det. Supt Kirkup explained how Robert made a statement and its contents were checked. Then when the Police told him his times didn't tally with Dorothy and Beatrice, he corrected it. It didn't sound as though he'd tried to deceive the Police or the Court.

Robert fell off his bicycle on the Tuesday afternoon on the journey from Dorothy to his home. This was the theme of quite some intense examination by the Court.

But science, even in 1938, could prove Robert was a murderer – or so the prosecution and the Police vainly hoped. But it didn't. Blood was found on Robert's clothing which was group II (A) but there was no evidence available to say what Robert's blood group was. It was possible that Robert's cooperation, so evident early in the investigation, was withdrawn when the lawyers appeared on the scene. The knife wasn't proven to be the murder weapon and even though the blood was the same group as Mrs Dobson's, it was also the same as 40 per cent of the population.

The knife was thrust into Mrs Dobson with such force it seems to have cracked a rib. As the knife was blunt, it pulled out some flesh when it was withdrawn (a sharp knife tends to increase the size of the wound). When the knife is in up to the hilt it is likely minute particles of tissue will lodge in the hinge. But the knife had been cleaned, or so it was argued. But the idea that this knife could have been cleaned with the thoroughness to remove all trace of

blood and/or tissue sits uncomfortably with the fact that Robert didn't attempt to clean his clothes or dispose of the handkerchief that he was supposed to have cleaned the knife with.

So the circumstantial evidence was as weak as the identification evidence and was as inconclusive as the forensic evidence. And then there was the changing evidence, and the disappearing evidence. At the end of this trial there could be a hangman's noose, was it fair to ask the jury to convict on evidence such as this?

Mr Morley for the defence was anxious to make a submission to the Court that this case wasn't safe to be left to the jury to decide. He made his submission, discussed later, and the jury did decide the case.

<div align="center">*</div>

Towards the end of the second day of the trial Mr Paley Scott concluded the case for the Crown. Mr Morley, for the defence stood:

> Mr Morley. 'My Lord, on behalf of my client I venture to submit to your Lordship – I do not propose to do it in detail – that there is here no case which could be safely left to the Jury.'
>
> Mr Justice Wrottesley. 'Would you like to make that submission in the absence of the Jury?'
>
> Mr Morley. 'I might, perhaps, be able to make it in greater detail.'
>
> Mr Justice Wrottesley. 'I am perfectly willing to listen to that suggestion tonight, but I do not think I need keep the Jury.'

This is an abridged version of Mr Morley's submission, but it highlights that there was no evidence. After each portion further details are given.

> I venture to suggest that the Prosecution's case here is: Assume the guilt of the Accused, and look how many little pieces of evidence are consistent with his guilt. My Lord, that is the complete inversion of the methods and principles which are usually adopted in criminal trials.

Usually in criminal trials a great deal of emphasis is put on the demands of justice being that the prosecution must prove their case: and there is no room for doubt. Evidence can take many forms – eye witnesses who actually saw the crime, forensic evidence that prove, for example, that the accused was at the scene of the crime, or that the scene of the crime was on him, such as blood from the victim. There are also murder weapons, macabre souvenirs taken by the murderer, and so on and so forth.

There is also circumstantial evidence where there is a known fact and an inference of another fact can be made. But it has to stand the testing of admissibility and cross-examination. For example, a man accused of stealing

a large sum of money where there are no witnesses and no direct evidence, suddenly pays off his mortgage and adopts a champagne and caviar lifestyle, buys a Rolls-Royce, etc. is good circumstantial evidence; a man accused of the same crime with no direct evidence and makes one minor lifestyle change – this would be weak evidence. Circumstantial evidence is said to provide links in a chain.

Another circumstantial evidence link: since the mid-eighties anyone's presence at the scene of a crime could also have been proved as he would have left DNA evidence, but this proves they were at the scene of the crime only, but it strengthens the case. Of course, DNA can be direct evidence, such as the semen evident on Mrs Dobson's body, or perhaps, more to the point, the absence of semen on Robert's clothing.

In Robert's case there was no circumstantial evidence, though the prosecution really did try hard, perhaps they did convince the jury that there was evidence – the conviction came from somewhere.

Mr Morley continued:

My Lord, if this case goes to the Jury the position which arises is this: that the prisoner has made a Statement which completely exonerates him if it is true. That statement has been tested by the Police with all the resources that they have, and they have agreed – from Supt Kirkup downwards they have agreed they have checked that statement so far as it can be checked and so far as they have checked it is true. If this case goes to the Jury the whole arrangements of trial are reversed, and the prisoner is put upon the proof of his innocence.

Again the point is clear. The accused does not have to prove he is innocent – this is the automatic assumption when he is tried; that he is innocent.

Mr Morley adds:

But, my Lord, there is the intrinsic improbability of the story: a young man of twenty-one – an undisputed fact – going to see his girl of about the same age, from half-past three to half-past four; going back to his house (which he undoubtedly did), changing his clothes and shaving; going back to meet his girl shortly after seven; and going again the next day to do exactly the same thing (which he was in the habit of doing) again at two o'clock, to meet his girl, a girl of his own age – the intrinsic improbability of the suggestion that in the interval between half-past four and seven he attacked and ravished and murdered this old woman of sixty-seven is so great that, my Lord, I venture to suggest it ought to weigh very much with your Lordship in considering the question whether this case ought to go to the Jury at all.

Apart from the fact that there was not a romance between Robert and Dorothy, it would be quite the accepted way of getting a romance off the ground. The way Mr Morley describes the afternoon and the evening sounds exactly the

way most twenty year olds (Dorothy was nineteen) lead their lives. And it is a bizarre and improbable occurrence to rape and murder an older lady in the meantime. With no previous form. There was the issue Mr Baldry raised about sexual matters, but bravado and twenty-year-old men make far more plausible 'bed fellows' than twenty-year-old men and twenty-year-old women.

Mr Morley pursues his point with some of the forensic evidence:

> But there is another matter which I think is of very material importance. The garments, the stains, have all been very carefully examined. Spermatozoa was found in the vagina and outside the vagina of the deceased woman. I venture to suggest to your Lordship that it is remarkable, if this was the man, that no sign of spermatozoa, semen, was found on his shirt or any of his clothes or anywhere, when the woman was matted with it. It is so remarkable that no sign of semen was found anywhere on him or his garments that, in my submission, this is a case which would not in the circumstances be fit to leave to the Jury. It is not as though he had washed himself – I do not know whether he had or not, but it is certain he had not tried to disguise any of the garments he was wearing. His blue overalls were the same, trousers and shirt and jacket were the same.

It sounds as though it would be unfair to leave the matter to the jury, they are sole judges of fact, but there seems to be no fact to judge.

In conclusion:

> I submit, having regard to the whole improbability of the story it is difficult to conceive that this man could have committed the murder; and in those circumstances, in my submission, the matter should not be left to the Jury for their consideration. I do not want to go into the matter in greater detail. I have made my submission broadly.

Mr Paley Scott, for the prosecution, certainly felt that the evidence was far less than was usual in a criminal case. But Mr Justice Wrottesley felt the jury should decide the case. What his feelings were is not known, sometimes after the jury have given their verdict and before sentencing the judge may add a few words of his own indicating agreement, but he didn't. However, there are more than a few fleeting comments in his summing-up to consider.

When the Court re-convened the following morning Mr Morley said a mere six words:

'My Lord, I call no evidence.'

Perhaps he was right to, but it goes against pure common sense to assume that because there's no evidence with which the jury will convict, it does not mean they will not convict. And there was plenty of evidence he could have called, but one has to ask if some of the evidence was actually disclosed to the defence or not.

*

No matter what, the jury will draw certain conclusions from one witness and, perhaps, none at all from another – and they will 'like' one witness more than another. They may not know which witnesses are telling the truth unless counsel exposes them, and will almost certainly be unaware that evidence is either being withheld or altered. And finally, they will judge some witnesses by appearance alone. So as that highlights a few of the likely weak points of a jury, it is of no surprise that at the end of a trial both Counsel for the prosecution and defence will deliver their final addresses and remind the jury how they have led them to the 'irresistible' conclusion of guilty or not guilty. Then the judge sums up – here it all comes again. There must be some relief when they get to the comparative tranquillity of the jury room. There their work really starts: they sift and discuss and debate the evidence, or what they have got of it; or what version they have got of it. And then they decide. But what the jury actually do is form an opinion – they can do no more than that. Any crook with sense, if he knows the evidence is overwhelming, will plead guilty and get off with a lighter sentence – whether parole comes any earlier with a guilty plea is a matter of contention. The legal establishment hold the jury in high esteem, which suggests that the legal establishment hide behind them. Or, does it mean the jury get it right? With the amount of convictions that are quashed each year it would seem not; on the other hand the Court of Appeal has been accused of rationalising, of quashing a conviction by finding some small procedural defect rather that overturning the verdict of a jury. But if the judge is fair and sums up properly then it will lessen the possibility of an erroneous conviction. So it is with this in mind that the summing-up by Mr Justice Wrottesley can be considered.

One observer (Donald Thomas' *Hanged in Error* – well worth a read!) has maintained that Mr Justice Wrottesley's summing-up was 'sympathetic to the defence'. There are several passages in the summing-up which support this; for instance, he says of one piece of evidence that this '... only establishes, not that he did do the murder, but that he might have done it.' And then right at the end of the summing-up he says this of the prosecution: '... they have got a number of things in regard to each one of which, when you test it, it amounts to no more than this, that it is quite consistent with this man having committed the murder: but it is consistent with him not having committed it.' If that does not indicate reasonable doubt, then what does?

In a summing-up there are a few issues the judge has to determine.

Firstly the judge makes good and sure that the fact of murder is not in doubt. Margaret Dobson was definitely murdered, she was stabbed twice and both stab wounds were '... death dealing blows.'

After the preamble of dismissing any doubt that the death of Mrs Dobson was murder, the judge starts his descriptions with the men delivering the livestock. And everything's alright if the assumption is that the judge does not

know that someone has been mucking about with the evidence. Mr Justice Wrottesley told the jury that the two men got about as near to an eye-witness account that the facts offer: 'So there you have, as I say an eye-witness account, not of the murder itself because only one figure was seen, but an eye-witness account of something which must have been a few seconds or perhaps a few minutes after the murder had been committed.'

But there's nothing in the official documents to even suggest an identity parade was held; and when one considers Robert was twenty not thirty and did not possess some of the clothes he was reported to have been wearing, and no mention of any reflection of the lorry lights on the glasses he wore does make one take a very deep breath.

In his next paragraph, the judge reiterates the demands of the criminal law:

> not convict the man unless on the evidence, and on the evidence alone, you are satisfied beyond all reasonable doubt that the Prosecution have got the right man. Let me perhaps illustrate that by adding one more sentence. It is not enough if you should think that very probably the Prosecution have got the right man. That is not enough.

He returns to events of the afternoon of the murder. Mr and Mrs Dobson had tea, Mr went back to work, Mrs started to prepare for the trip to the shops. It is unfortunate the judge says that Mr Dobson saw his wife go down the farm track at half-past four when Mr Dobson clearly gets all of his other timings wrong.

And he perpetuates one of Mr Dobson's errors in the timing about when the threshing party arrived: 4.30 p.m. (it was 3.30 p.m. – 4.30 p.m. was the time they left). And, corrected by Mr Morley, the judge tells the jury that 'So apparently that little party of three men went down this road ahead of Mrs Dobson ...'

An important consideration is Mr Dobson said he saw his wife go down the track without a shopping bag, and this might be quite a lot more important than first thought. She would have had to have gone back into the farmhouse to get her bag. The only possible scenario now is that while she is in the house Mr Smith and the thresher party go down the track. However, Mr Justice Wrottesley does say 'The times, of course, are not correct times.' He then tells the jury 'You may very well think that in that particular Mr Dobson was not accurate in his memory.' So what are the jury to believe of Mr Dobson's description of the afternoon? I draw attention to this because when Robert makes a mistake, Mr Justice Wrottesley's comments are quite in contrast.

The judge goes back to when the livestock delivery lorry arrives and what the men see: 'At half past five there was that incident of the two men.' On that lorry were three men. His summing-up now includes evidence which is in error; but it suggests the judge was not in on the plot to remove John Burns from the evidence.

Mr Justice Wrottesley then describes Robert's afternoon. It is understandable that his Lordship leaves out some of the witness evidence about Robert's head-gear. He said himself he wore a cap, so common sense would dictate. Robert moves towards Wolviston and visits Dorothy and the judge reminds the jury Robert was said to have been wearing a cap '... upon which a bloodstain was said later to have been found.' He should also have added that there was no possibility of discovering how long the bloodstain had been on the cap, and that the amount of blood was too little to be grouped surely rendered this evidence superfluous. And the blood seems to have moved from the right side of the peek when Dr Cookson examined it, to the left side when Dr Roche Lynch examined it.

The judge goes on: '... the prosecution ... point out ... there are other circumstances of grave concern.'

Robert was in Wolviston on 18 January, a Tuesday, and also 19 January but at different times, and in the statement he made to the Police he gives his timing for Tuesday and Wednesday to be the reverse of what they were. At any rate the timing for the Wednesday he attributes to the Tuesday – that he left Wolviston at 3.30 p.m. The Police checked his timings and found this error. Robert told them who could verify his activities of the Tuesday afternoon – Dorothy and Beatrice. So considering what Mr Justice Wrottesley said about this, can the '... circumstances of grave concern' be identified. The grave concern is that Robert said he left Wolviston at 3.30 p.m. when actually it was over an hour later at 4.40 p.m. But according to Mr Justice Wrottesley, (and the prosecution, and the Police for that matter) the consideration was that by saying he left Wolviston at 3.30 p.m. he could give himself an alibi. This is untrue; it does not give him an alibi. If Robert left Wolviston at 3.30 there's no further sighting of him until about 5.00 p.m. So it is not clear as to where the alibi is. Robert could have encountered Mrs Dobson on the track, took ten minutes or so to do what was done, and cycle home. There's a plus and a minus to this theory; the plus is that with a timing of about 4.30 p.m. it would tie in with the pathologist's report that Mrs Dobson died about half an hour after her last meal (taken between 3.15 p.m. and 3.30 p.m.) at the earliest, and about three hours at the most – it is likely to be nearer the half hour than the three hours as no food at all had left her stomach. However, the minus to this theory is that a man was seen where the body was later discovered between about 5.10 and 5.30 p.m. So to go back to the judge's 'circumstances of grave concern'; this seems in error. By telling the Court Robert left at 4.40 p.m., if the defence was of any use at all and called Robert's father (who told his mother Robert was home at 5.00 p.m.) and his neighbour, then the matter would be proven that this 'circumstance of grave concern' was a folly. But this is how Mr Justice Wrottesley summed up this evidence. He quoted Robert: '"I left and went to Wolviston, where I stayed until half-past three"'. And the judge says: 'Now that, I think you will say, was obviously not true. At any rate it is so ambiguous as really to amount to misleading the Police.' Mistakes usually mislead, but the Police cleared it up quite quickly and efficiently. But one wonders

what Mr Justice Wrottesley, by saying this, conveyed to the jury. It seems he has one attitude to Mr Dobson's errors or mistakes or misleading comments, but quite another attitude to Robert's.

Over the next few minutes the judge says of Robert's description: 'Now that is not true, obviously' [and] '... he gives an account which is not a true account' [and] 'He gives an account of his movements which is not the truth.' This seems excessive. The judge sums up this particular part of the evidence thus: 'So his story turns out not to be true.' Perhaps one cannot really blame the judge because some important evidence has not been put before the Court.

Thankfully he dismisses the next piece of evidence on which the prosecution rely and that is the reporting of Robert's demeanour by Mr Smith, Mr Collins and Mr Fulcher outside the newsagent's shop the evening after the murder. '... treat that evidence with great caution.'

The prosecution also relied on scratches on Robert's face to prove he had attacked Mrs Dobson, and she defended herself. There was no forensic evidence, such as blood or skin under her fingernails, to support this.

It is quite repugnant to imagine the attack, but a necessity. A twenty-year-old man hits a lady of sixty-seven with his fist. A lady of small stature. Would the first blow have rendered her momentarily shocked and a little disorientated? The second would really subdue her. Then she is bundled down a slight embankment and raped and stabbed twice. It is difficult to see how she could possibly have lashed out, with much force under that onslaught. There was blood on the gloves but it is not unknown for a victim of a stabbing to hold their wound; it would have taken her about five or six minutes to die.

As for the scratches on Robert's face, he attributed them to falling from his bicycle. This could be doubted but not disproved.

Mr Justice Wrottesley says of the attack: 'Now you will probably think that Mrs Dobson did not succumb to the ravishing and the murder without doing something to defend herself.' It is difficult to see how, but these days we know a lot more about violence and its effect. The judge probably knew a lot about evidence and rules of evidence and the law. He does not seem to know much about the behaviour of a victim or the effect of sudden violence and shock.

There was a great deal of debate about the 'blood' evidence which was discussed earlier, but to briefly recap. The two sources of evidence were from Dr Cookson and Dr Roche Lynch. Earlier DS Lee asked Robert if he could examine his hands and reported that no cuts or abrasions were noted but, as importantly, as Robert 'bit' his fingernails it did not appear that there was blood underneath them. A little more than Dr Cookson found under Mrs Dobson's fingernails. Blood was found of group II (A) on much of Mrs Dobson's clothing; Mrs Dobson was blood group II (A). The blood on the nail groove on the pocket knife was insufficient to identify if it was human or not. Robert's shirt cuffs were stained with blood of group II (A) and blood was found on his handkerchief of group II (A) and a small amount of blood on the right/left side

of the peak of the fawn cap. Dr Cookson found no trace of blood on Robert's shoes, raincoat or vest. Nor could he find any on his jacket or overalls. In his report, he does not say whether he found blood on Robert's trousers or not. Dr Roche Lynch did find blood on Robert's trousers and the jacket, though the amount was too small to group. He concurred with Dr Cookson on the shirt and handkerchief; he also agreed there was no blood on the raincoat, shoes and *brown* cap – Robert was wearing a fawn cap. Dr Cookson found blood on the right side of the peak, but Dr Roche Lynch found blood on the left side.

The pocket knife Robert had gave no evidence that it recently pierced a body. On considering the thought of Dr Cookson's that the force the knife was thrust at could have been enough to crack one of Mrs Dobson's ribs, then the knife would need very careful cleaning. In the lab they dismantled the knife but still found nothing incriminating.

Finally, Mr Justice Wrottesley comes to discuss particles of hair found on Robert's and Mrs Dobson's clothing. The hair did not prove anything: 'Well, again I think it is best to describe that by saying it does not amount to proof.'

Regarding the footprints, 'There seems to be nothing corresponding with a dying struggle ...' probably because with the 'fist-delivered' injuries Mrs Dobson is likely to have been knocked senseless. That suggests there was no 'dying struggle' in the plough (the field off the track where the body was found), so where would Mr Justice Wrottesley place Mrs Dobson and her attacker, Robert, (although this is hypothetical) when she scratched his face – that is part of a struggle because it means some kind of physical confrontation occurred. And it is clear Mrs Dobson sustained at least two blows to the face/head. It is not conceivable that Robert sustained a scratch and Mrs Dobson a couple of punches, and they then 'walked' towards the plough. More likely, if Robert punched her and this had an effect he would have had to (to a greater or lesser degree) drag her to the plough. Surprisingly, it is unclear if the track was of loose material, which would show a struggle, or was made up of compacted material, which may not; but it is equally as unclear where Mrs Dobson made the attack on Robert's face: so is the scenario that Robert attacked her by punching her a couple of times and removing her from the track to the plough and that it is here she scratched him? This is speculation but it would seem that for one person to scratch another in the way suggested, they would have to be facing them with a distance of about eighteen inches or so between them. But would she scratch or would she slap? Either way, if Robert attacked her then it is likely her opportunity to scratch him on the face, as it is described, would be limited. But most women will slap with an open hand rather than scratch – a slap would be more instinctive.

Digressing yet further, what does this theory say about the experiment with Dr Cookson's secretary, when she experimented with a gloved hand (Mrs Dobson's gloves) to scratch Det. Supt Kirkup, observed and reported by Dr Cookson. Mr Morley elicited from Dr Cookson:

Question. 'You conducted an experiment by the hand of your secretary on Supt Kirkup. The experiment seems to have terminated before the result was achieved, did it?'

Answer. 'Yes, it was clearly foreshadowed what the result would be.'

But how did Det. Supt Kirkup and the secretary 'line up' for this experiment? Did Det. Supt Kirkup unleash two blows to the secretary and propel or drag her a certain amount of feet? Or did she calmly swing at his face until the experiment was 'foreshadowed'. Then extrapolate to a lonely farm track late in the afternoon – presumably the rapist/murderer would stand awhile for the scratches to be made.

Mr Justice Wrottesley goes on: the footprints '... does leave unexplained the one footprint found close beside the woman.' So it is proved that a murderer was there; it is not proved that Robert was there.

Mr Justice Wrottesley will be quoted at some point or other by any historian writing of this case: 'they (the prosecution) have got a number of things in regard to each one of which, when you test it, it amounts to no more than this, that it is quite consistent with this man having committed the murder: but it is consistent with him not having committed it.'

With only suspicious circumstances, and those are a matter for debate, one wonders how Robert could possibly have been convicted: '... if, ... you think that it all amounts to this, that very likely that young fellow did it, but we cannot be certain – if that is the frame of mind you are left in, then your duty is equally plain, and it is to say 'Not guilty'.'

Mid-way through the jury's deliberations they asked for Robert's statement and also for his bicycle to be brought into the jury room.

Their verdict was guilty.

*

The jury decide the facts of the case; the verdict is a fact because that is what they think; so it reflects their state of mind, but their state of mind must have paid attention to, and applied the evidence of the case. So what the judge said in his summing-up is intrinsic to the jury's deliberations. If the convicted man feels there are grounds to suppose the judge or jury did not apply their attention to the case then he can appeal.

Robert's appeal took a number of points (his appeal details are in italics), and each is discussed.

That the judge was wrong in law in refusing at the close of the case for the Crown to withdraw the case from the jury and direct a Verdict of 'Not Guilty.'

This would be a matter of law and the lawyers are best placed to answer this. Mr Morley asserted there was no case to answer. Mr Paley Scott confessed there was far less evidence than one usually finds in a criminal trial. It is a fact that by the end of the twentieth century the case would never have gone to Court on the evidence available. Leaving aside DNA evidence as it had

not been developed, the identification of the man by the men in the lorry delivering livestock would be wholly inadequate. The evidence of Mrs Teale would have to be disclosed, although it is fair to say that when she observed Robert it was from a bit of an oblique angle, dark and only momentarily: but on the other hand she knew him so it would be more recognition than identification.

The Bar Counsel has guidelines to ensure Counsel do not fail their clients as Mr Morley failed Robert. But this case was in 1938. It was simply the case that the trial judge thought the case should go to the jury. It is the type of legal argument which is quite common.

That there was no evidence fit to be left to the jury that I was guilty of the offence charged.

There was little or no evidence to take the case to Court. It seems strange it went even that far, let alone to conviction.

That the evidence given at the most amounted to evidence of suspicious circumstances and was consistent with my innocence of the offence charged.

When Robert's advisers argued that the case against him was based on suspicious circumstances only, then they may be putting it too strong! There was no evidence: eye-witness, forensic, circumstantial (no 'chain' of linked events). It is difficult to see any rationale to this case going to Court.

That in directing the jury the judge failed to put before them the following matters: The evidence that tended to show that I could not be the man who was seen by the witness Swales at the scene of the crime.

Robert draws attention to Mr Swales. Mr Swales was mistaken about age and about clothes. And there's no mention of an identity parade.

The evidence that no trace of semen was found upon my shirt or clothing.

A serious failing by the judge. Semen would have had to have come into contact with his clothing, and would visibly stain. Mrs Dobson's genitalia was described as 'matted' with congealed semen. It was highly unlikely she would have gone out from home in that state, and as she was sixty-seven and the possibility of a long-married woman meeting a young lover of half her age (or younger) to have sex, and in a field, and in January, somehow lacks plausibility. So the semen evident on Mrs Dobson's person almost certainly came from the rape; and, considering its position, it is inexplicable no trace was on Robert's clothing, unless he was innocent.

The evidence that I had not tried to conceal articles of clothing belonging to me which bore blood stains, or my bloodstained handkerchief, or to remove the blood from them; and that I wore and carried the same to the Police Station on 20th January.

The bloodstained clothes did not prove the blood came from Mrs Dobson. It only proved it was the same blood group, and the same as 38–40 per cent of the population. The blood on his cap moved from one side to the other so one is left with a question of the accuracy of the scientific experts, if not their competence.

That the judge mis-directed the jury as to the effect of the evidence in the following particulars:

As to the likelihood of my going to High Grange Farm on the 18th January for the purpose of seeing the witness, Smith.

All of the statements show people he had only known a matter of months, so it is impossible to say how long he had been in agricultural work. And as it was his father who had been dismissed and made the threats to Mr Dobson five years before, then the Hoolhouse family may have been unaware that Mr Dobson had 'banned' them from working there. But there's no evidence at all that Robert was keen to continue working in agriculture, so it is unlikely he was looking for Mr Smith at any time during this period.

By telling them that the first part of my statement to the police was obviously not true, whereas its truth or falsity was a question for the jury; and by failing to tell them that my corrected statement equally exonerated me.

The jury should have considered the fact that either he made a mistake or not. The fact that he gave the Police all details to check his story tends to suggest it was a genuine mistake. Did what the judge say, i.e., '... that is obviously not true' lead the jury to think Robert was trying to deceive the Police or the Court, or them? By telling the jury that Robert made the original statement with the earlier time of leaving Wolviston was so that he gave himself an alibi is an assumption, and not an assumption supported by facts. As for what the statement said exonerated him, Mr Morley should have called witnesses to prove this.

By telling them that while the evidence to the blood group of the stains found on my clothes could have been negative if it has [sic] been known that my blood belonged to the same Group, they were entitled to consider it as being some evidence against me, seeing that there was no evidence as to the Group to which my blood belonged.

Robert's blood group was not evidenced in the trial. So is it fair that the jury consider it? It might be difficult to prevent them from doing so as it was such a key question. But he is addressing what the judge told the jury. If it is evidence then the judge should ask the jury to assess the facts of it, but Robert's blood group was a matter for guess-work, possibly it was reasonable to guess in the circumstances, but a guess cannot become a fact without supporting evidence. And this should have been emphasised to the jury.

By telling them that it was open to them to explain the unidentified footprint beside the body of the deceased as being that of the doctor or a police officer, the evidence being conclusive against such an explanation being possible.

The unidentified footprint had no features of identification with Robert's footwear. The footprints did not prove he was there. Considering the footprint may have been that of a police officer or the doctor does not seem to help the case – but considering the footprint could not be proved as Robert's seems conclusive.

By telling them that at 3.25 p.m. on the 18th January my mind was undoubtedly running on the subject of sexual intercourse.

For a twenty-year-old man not to think of sexual intercourse several times an hour would be unusual. But although rape has a sexual element, it seems to be more a crime of 'power of one person over another' than sex. Sexual intercourse is a mutually pleasant experience, not an intrusive episode of brutality. Men and/or women who enjoy a robustly physical sexual experience (a bit rough) are not rape fantasists, no more than gun sportsmen are murder fantasists. The thought patterns one might expect would be: sexual intercourse – pleasure; rape – brutal violence. But going back to pleasant twenty-year-olds and a 'bit of dick' – more toward the sexual intercourse model, but there's the question for twenty-year-old men of bravado – most twenty-year-old men (grossly) exaggerate their sexual prowess.

By telling them that they might consider a number of circumstances each of which was in itself merely suspicious as together constituting evidence of guilt.

What Mr Justice Wrottesley said was:

'Do all these circumstances, suspicious though they are, or may be – do they convince me beyond all reasonable doubt, beyond the possibility of mistake, that that young man murdered that old lady?'

There was no attempt to marry up all of these circumstances, so if they remained isolated then they remain isolated. It was not as though there was a circumstantial 'chain' of events that would lead one to the conclusion that the whole was the sum of the component parts.

That the verdict was against the weight of the evidence and such as the jury could not reasonably have found if they applied their minds solely to the evidence given.

The definition of evidence is: information that gives grounds for belief, and belief is an idea accepted as true. There were a number of issues the prosecution said were suspicious:

Presence of a man at the scene of the crime – the evidence here was incomplete or not reconcilable to Robert; a vague opinion based on incomplete and only partially seen evidence is not reliable.

Robert changed his statement. He corrected it. The idea that the 3.30 p.m. departure from Dorothy and Beatrice was an alibi only the killer would know cannot be supported by the facts. And the following day he left at 3.30 p.m.

Blood on his clothing. Same group as Mrs Dobson and 40 per cent of the rest of the population. It could not be proved it was relevant evidence. A tricky one, but if the Police had taken Robert's blood and it was not group II (A) then it might have spurned Mr Morley into doing his job right. If the blood was group II (A) then Robert should have been released due to lack of evidence.

Whereabouts at time of murder unknown. False. Two sightings which were timed at a twenty-minute cycle-ride apart. There was an approximate time he departed from Dorothy but a more definite time he was in his back garden: this could have been timed by the train.

Robert and Mr Dobson at loggerheads. Partly right. It was five years before, and it was Mr Hoolhouse senior who fought with Mr Dobson.

Robert's demeanour at the newsagent's shop. Misleading, and the judge said so.

There was no eye-witness, forensic or circumstantial evidence to tie this case together.

In the Court of Appeal, the judges hid behind the jury. They did not comment on Robert's assertion that his conviction was against the weight of the evidence. This is the concluding paragraph of the Court of Appeal judgement:

> ... it appears to us that the comments which are made with regard to this summing-up, are not sufficient to induce us to say that the learned judge left anything unsaid which he should have said, or said anything which he should not have said in the course of it. The case remains one upon which there was, in the opinion of this court, evidence upon which the jury might fairly act in finding the accused was guilty of the crime with which he had been charged, and that being so, the inevitable result is that this application must be dismissed.

Robert was entitled to apply to the Home Secretary to commute the death sentence.

<div align="center">*</div>

There's no doubt that the way Robert's verdict went was unfortunate, and perhaps it is not surprising that the Court of Appeal took the line they did, they have always been reluctant to upset the verdict of the jury; of course how the jury reached that verdict is anybody's guess. But Robert could appeal to the Home Secretary whose role was to decide if there were grounds to seek intervention from the Sovereign, or put more plainly could the Home Secretary ask the King to commute the sentence or even give him a pardon. The Home Secretary at that time was Sir Samuel Hoare who was actually an advocate for penal reform and the abolition of capital and corporal punishment. Underneath him, his department at the Home Office was managed by a Permanent Private Secretary (PPS) who was a very senior Civil Servant. If the Court of Appeal's role in the case was unfortunate, then the role of the Home Office was disgraceful.

Before the documents arrived on Sir Samuel's desk they had been with Sir Alexander Maxwell, the PPS. Fourteen thousand local residents of Durham signed a petition pleading for Robert's life. No doubt they all agreed that the crime should not go unpunished, but the case was so weak they could not just stand by and do nothing. Not forgetting it was 'one of their own' who had been murdered, and it *was* a particularly wicked murder, they still felt they should do something. And they were not alone. All bar a couple of the serving Durham MPs also wrote personally to Sir Samuel – true they were all Labour politicians and Sir Samuel was a Conservative, but party politics would always take a back seat for matters such as this. And the official organisation petitioning for the abolition of Capital Punishment who

were reluctant to voice concern about an individual case, also pleaded with the Home Secretary. All to no avail.

The fourteen thousand signatures were more or less ignored.

The jist of what the MPs wrote was a suggestion that Sir Samuel could suggest Robert was not quite well psychologically at the time of the murder. But the psychiatrists felt he was fit to plead, had no significant history of insanity and so on. However, Robert was not by any means an intellectual 'high-flyer'; he was said to have a mental 'age' of thirteen and a half. The MPs argued that there was:

'... no clear motive why Hoolhouse should have done it; and if he did do the crime surely on psychological and medical grounds he should be detained during His Majesty's pleasure. The details of the murder are considered peculiar.'

But as a psychiatrist's view was that Robert was fit to plead, the ten Durham MPs attracted this comment from Sir Alexander:

As regards the suggestion that on "psychological and medical grounds he (the prisoner) should be detained during HM's pleasure," this prisoner is not suffering from any mental disease or defect; and this suggestion can only be regarded as an extreme example of the tendency to ignore the principle that the object of the penal law is not merely to check the criminal propensity of the particular offender, but to deter others from committing similar crimes.

A bit strong.

It 'can *only* be regarded as an *extreme* example' 'only' – is there no other possible explanation for ten MPs voicing concern, and is the word 'extreme' at all appropriate. Sir Alexander goes on: 'ignore the principle that the object of the penal law is not merely to check the criminal propensity of the particular offender, but to deter others.' It does not seem at all as though the MPs are ignoring any principle, they were pleading for another man's life. Undoubtedly it would certainly check Robert's criminal propensity – he did have a conviction for stealing pigeons and it would not therefore be an idle assumption that pigeons slept more peacefully in their beds following his execution. Did it deter others, if Robert was not guilty of this crime, then did it deter the real culprit?

Sir Alexander also commented on Robert's activities on the afternoon of the murder. He wrote in a report to Sir Samuel '... No confirmation as to the time at which the prisoner arrived home could be obtained.' This is quite simply not true. Even Det. Supt Kirkup noted Mrs Teale's evidence, and taken with Dorothy's which said Robert left her at 4.40 p.m. and PC Chapman who stated the cycle ride took 20 minutes. And Mrs Teale saw Robert at a time that could have been roughly fixed.

It is true is that no evidence was offered in Court to prove he was at home at 5.00 p.m., but it is clear when the next issue is discussed that Sir Alexander had a lot more documentation than one might think, and it is highly likely he knew that Robert was at home at 5.00 p.m.

Sir Alexander pushes matters further from fact.

A man called Thomas Herron, who was a van driver, made a statement to the Police in which he said he had seen a man on 18 January at about 5.45 p.m. whilst driving his van and that 'I know Hoolhouse by sight and am of the opinion that the man ... strongly resembled him.'

But in a later statement Mr Herron said:

'I recognised him as a person whom I knew by sight who had been employed as an Auxiliary Postman at Haverton Hill about the Christmas of 1937 ... I do not know the name of the Auxiliary Postman whom I overtook but I would recognise the man I overtook if given an opportunity even if he was placed with a number of other men.'

So the Police had an opportunity to prove Robert was on his bicycle at 5.45 p.m. between the farm and his home. This might seem a damning piece of evidence but Mr Herron went on to say:

On Wednesday 16 February 1938, I attended an identification parade at Stockton Police Station, where I saw thirteen men, all dressed more or less in similar clothing and all wearing glasses. I was asked to pick out the man who I had seen on the Cowpen Bewley Road on the evening of the 18th January, at 5.45 p.m.

He did not pick out Robert, therefore the man he saw was not Robert. Sir Alexander is to refer to this piece of evidence.

The last couple of paragraphs (above) suggest Sir Alexander had most, if not all of the documentation for the case, including statements not given in evidence. Therefore if he had Mr Herron's (and he quotes sufficient detail from it to suggest he had), then one has to ask whether he had the statements of Mrs Teale, Dorothy and PC Chapman and he had the intellect to marry up the three, even if no one checked with the Railway Company.

Sir Alexander was keen for the Home Secretary to see the trial judge, Mr Justice Wrottesley and sends Sir Samuel a memo to this end.

'The Appeal has been dismissed and the execution fixed for Thursday 26th May. See memo written suggesting consultation with the judge. AM 18/5'

18 May was a Wednesday. The following Tuesday Sir Samuel notes:

'I have discussed this case with the judge and I am clear that the sentence must take its course. SH 23/5'

So what was it that Mr Justice Wrottesley said to the Home Secretary to make him (a dedicated abolitionist of Capital Punishment) feel '... clear that the sentence must take its course'?

Sir Alexander speaks for him:

The Secretary of State saw the judge and the judge said he had no doubt that the verdict of the jury was right. He said he also consulted the three experienced judges who sat in the Court of Appeal and they all took the view that there was no doubt as to the prisoner's guilt.

The judge pointed out that apart from the evidence called there was an important piece of information which '... the police could not use.' And he gives a résumé of Mr Herron's evidence before he says:

'Thomas Herron failed to identify the prisoner at an identification parade. If Herron's evidence had been available, it would have destroyed the prisoner's statement that he got home at 5 o'clock." AM 24/5'

Mr Herron did not fail to identify the prisoner, he was not asked to identify the prisoner. He was asked to identify the man he had seen at 5.45 p.m. on the evening of 18 January. There was no proof that Mr Herron saw Robert. It also seems quite bizarre that the judge would discuss this 'evidence' which assumed Mr Herron made a mistake at the identity parade, especially if that evidence had not been before the jury. Sir Alexander makes it clear that the Home Secretary, Sir Samuel Hoare, decided Robert was guilty after the meeting with the judge when this evidence of Robert's identification was assumed to be wrong.

It also begs the question: if Mr Justice Wrottesley knew of this evidence then what else did he know?

Sir Samuel later said:

'Am I certain that, during my two years at the Home Office, twenty-four murders were rightly reprieved, four rightly sent to Broadmoor, and nineteen rightly executed? I cannot honestly say, "Yes".'

So what could he have honestly said?

This was a case of weak evidence, which did not prove Robert murdered Mrs Dobson. There was no evidence of any description to convict, and what evidence there was, was tampered with.

In opening this consideration I asked: 'If the jury heard all of this, what would their decision have been?'

Robert was convicted and hanged following a chain of events which started with him making a mistake in a statement to the Police. If these arguments can be supported by the facts of the case, which they can, then Robert could not possibly have murdered Mrs Dobson, and so the murder of Margaret Jane Dobson on the afternoon of Tuesday 18 January 1938, remains an unsolved murder.

ACKNOWLEDGEMENTS

This is one topic that this writer has difficulty with, not because I do not know who to thank, but because the mere words here will not convey how much I owe to just a handful of people, and how grateful I am for their contribution.

All management and staff at The National Archives in Kew and the British Library Newspaper section in Colindale have, and probably without realising it, helped enormously in producing documents, and in liaising with other agencies to gain access to documents.

The Libraries of Leeds and of Durham were equally as helpful and can respond to a question with a detailed answer in a mere few minutes!

Charlie Templeton deserves thanks for his help with the restoring documents, and Kelly Hope in making sure this document; this book was suitable for submission. Many thanks to Alan Moss, formerly of Scotland Yard, whose knowledge and resources were of considerable use.

Thanks to Bob O'Hara for the help with research.

To Claire Macdonald whose illustrations are more than amazing.

And to the Staff at Amberley Publishing for their professionalism and determination to make this project possible.

But above all else to Sarah Flight at Amberley whose patience and quiet determination makes you believe it is possible too.